Drawing

A waterfall, near Vevey, Switzerland 1781 *by Francis Towne. Pen, ink and monochrome wash. Royal Albert Memorial Museum, Exeter.*

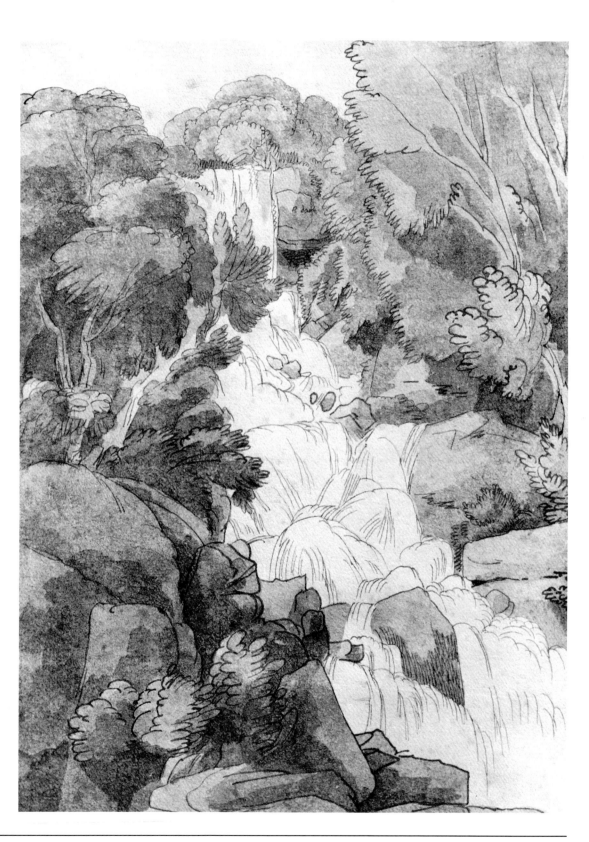

Drawing

Robin Capon

B.T. Batsford Ltd, London

Make the most of your talents: how silent the wood if no birds sang save those that sang best.

Acknowledgements

I should like to thank the following for permission to reproduce photographs and illustrations: Blackburn Museum and Art Galleries, pp. 9 [2], 49 [5], 57 [4] and [5], 61; The British Museum, p. 79; B. T. Batsford Limited, pp. 6, 17 [9]; The Burrell Collection, Glasgow Museum and Art Galleries, p. 74; Rachel Capon, pp. 12 [3], 51 [3] and [4], 54 [1] and [2], 55, 58 [1], 59 [2] and [3], 67 [4], 73 [2], 78; D.A.C.S. p. 25 [3]; Glynn Vivian Art Gallery, Leisure Services Department, Swansea City Council, pp. 11 [5], 15 [5], 21 [4]; National Museum of Wales, Cardiff, p. 37 [4]; National Portrait Gallery, London, p. 47 [4]; Royal Albert Memorial Museum, Exeter, pp. 2, 24, 49 [4], 60; The Tate Gallery, London, pp. 7, 19, 25 [3], 33, 83; Williamson Art Gallery and Museum, Metropolitan Borough of Wirral, pp. 49 [3], 75, 85; Windsor Castle, Royal Library, pp. 35 [4], 72.

Also, many thanks to my editor, Louise Simpson, for her help and advice in the preparation of this book, to Samantha Stead for her editorial work, and to my wife, Tricia, for her unstinting enthusiasm and untiring word-processing!

Woolfardisworthy, North Devon 1990 RC

ISBN 0 7134 6421 6

Typeset by Tradespools Ltd, Frome, Somerset
Printed in Hong Kong
for the publishers
B. T. Batsford Ltd.
4 Fitzhardinge Street
London W1H 0AH

CONTENTS

INTRODUCTION

Can you make a mark on a sheet of paper? Then you can draw! This is not to say you are an artist, of course, but you have the basic qualification to become one.

When you draw you are simply making marks on a sheet of paper or other suitable surface. You might draw with a soft drawing medium, like charcoal or pencil, which easily breaks down on contact with the paper to leave lines and marks. Alternatively, you can draw with a fluid medium, like ink or paint. There are lots of media and methods to try.

Sometimes, like me, when you are half-listening to someone on the other end of the telephone, you will just scribble or doodle. In fact, this isn't a bad way of trying out a new drawing medium. But usually a drawing is made for a particular reason. When you draw you are expressing your ideas about something and you want to communicate them to other people. You might be the sort of person who can do this with complete, uninhibited feeling and freedom of

1 *Satirical drawing, source unknown*

expression or you might want to do it in a totally objective way. It is a good idea to start with work based on careful observation and analysis in order to learn some of the fundamental principles and techniques. But ideally, a drawing, like handwriting, will reflect personality and tell us something about you, the artist, as well as your ideas.

I believe everyone has some form of creative ability that they could develop. To many, drawing is a basic and natural way of expressing and communicating. If you look at the history of mankind you will see plenty of evidence of drawing, right from the earliest cave-dwelling and primitive peoples through all groups and civilizations to the present day. We are all born with the ability to draw, and indeed, our first marks are in the form of drawing rather than writing. What is more, drawing is not restricted by the frontiers of language. A Leonardo drawing is good in any language!

It is such a pity that for so many the instinctive desire to draw and the joy and delight in drawing is soon lost. Education is at fault, as is a society that encourages the worship of computers, and artificial and mechanical means of making images, in preference to those from the hand of the artist and illustrator. Drawing, like all the fine arts, needs the right sort of recognition, environment and encouragement.

Drawing is a continuous, developing activity for everyone. If you stop drawing for a number of years then, like anything else, you become out of practice. But however out-of-sorts your drawing feels and however inadequately you rate your ability, with the right sort of exercises and encouragement you can soon begin to improve and develop your drawing.

Ability is not necessarily the key factor towards successful drawing. Ability is hard to quantify anyway. What is more important is your willingness to persevere and experiment. You need to expose yourself to a wide variety of drawing situations. Drawing is as much a process of self-discovery as anything else, a matter of finding the right path to develop. The real satisfaction of creating a successful drawing more than compensates for any hard work involved.

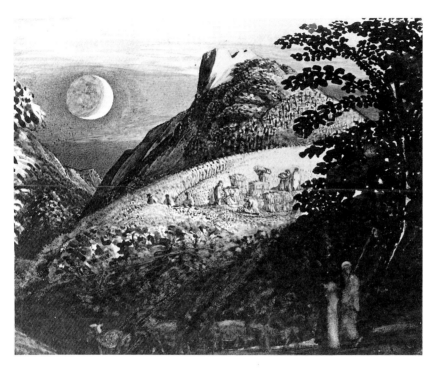

2 The Harvest Moon:
(Drawing for 'A Pastoral Scene'), by Samuel Palmer. Ink and gouache.
Tate Gallery, London

We all want to draw well. So what is a good drawing? This is not easy to define because individual interpretation and preferences play their part. You might think that obvious technical skill and realism are important factors, whilst other people will value originality and individuality. Certainly we cannot measure the success of a drawing simply in terms of the amount of effort and detail lavished on it. A line drawing of a nude by Matisse, for example, might well convey more power, interest and immediate information than a highly worked drawing of a similar subject by a Renaissance artist. An effective drawing might consist of only a few lines or tones, just as it could be composed of an involved design and elaborate detail. One of the great fascinations of drawing is the variety of possible approaches and techniques. Artists see and interpret in different ways, just as the viewer finds one type of drawing more appealing than another.

Look at the two entirely different drawings on these pages. The satirical *Punch* illustration **1** exemplifies the power of this type of drawing. Here there is a need to simplify, distort and overstate in order to make the greatest impact. Whereas in the

drawing by Samuel Palmer (illustration **2**) the mood is pastoral and Romantic. The composition and forms are more subtle and the picture more intense in personal feeling. These are just two types from the wide range of drawing techniques and approaches. Looking at drawings like these and the various other types you will come across throughout this book will help you to appreciate the scope of the subject, as well as find particular artists, techniques or ideas to follow up.

It has been said that drawing is the most demanding activity there is. When you are drawing you are looking, thinking and doing almost simultaneously. Don't be put off by this! See it as a challenge! You will need to be inquisitive and enquiring in what you do and aim to develop an awareness of different materials and techniques. But above all, believe in yourself. Not every drawing will succeed. Even the best artists have days when the waste-paper bin is the only thing that benefits!

This book is for everyone interested in the subject of drawing – especially the beginner. Its aim is to introduce all the main aspects of drawing from practical and technical issues through to philosophical and critical standpoints. From information on media and equipment you will see how to develop different techniques, draw particular shapes, research and plan ideas and projects, and present your work to the best advantage. The content is subdivided into specific topics, with each topic covering a double-page spread. Topics can therefore be readily identified. You can work through the book in sequence or pick out topics that you particularly wish to concentrate on.

Above all, drawing is to be enjoyed. You will learn from the advice, wisdom and experience of others, but don't be afraid to be influenced by your own personality and ideas.

So now let's do some drawing!

TRYING OUT DIFFERENT MEDIA
and EQUIPMENT

You will soon find that each drawing medium you work with, whether pencil, charcoal or whatever, has its own characteristics, strengths and limitations. Therefore the choice of medium has a big influence on the appearance and impact of the final drawing.

Choosing the best drawing medium for a particular idea is a matter of experience and practice. Help yourself to develop a familiarity and confidence with each medium, as well as establish a variety of different skills and techniques, by trying out a wide range of drawing tools and media. This will give

1

breadth to your work and will mean that you are able to convey your ideas in the most effective manner.

Notice how the drawing medium influences the result by comparing the two drawings in illustration **1**. With the pencil drawing (*left*) it is possible to employ a subtle range of tones and to be quite precise in approach. Contrastingly, the pen and ink technique (*right*) is less realistic, though the

medium creates a positive and lively drawing. Arguably, this is the more interesting.

Sometimes it is a good idea to combine several media. George Morland's drawing (illustration **2**) uses a mixture of pencil and chalk. Using two or three media in this way means you can extend the possible range of techniques and effects. Some media, like chalk, will suit general tones and background effects, whilst others, like pencil, will give the detail and emphasis you require. But one medium will not always combine sympathetically with another. Again, build up experience by testing out different combinations to see if they work.

Pencils

Perhaps because it is the most common drawing implement, the pencil is often underrated. In fact, it is one of the most versatile of media, and the one which will most obviously reflect your drawing ability.

Modern pencils are made of bonded lead or graphite glued into a casing of soft wood. The usual range of drawing pencils is from 2H to 6B. 'H' indicates the degree of hardness of the pencil and 'B' the softness, with HB as a medium grade. You will find that the feel and response of a pencil varies from one manufacturer to another. Try out various makes until you find one which you like. In my drawings I normally keep to a range within H to 3B.

Try out carpenters' pencils and graphite sticks for general quick sketching and shading, and propelling pencils for adding sharp lines and details. Also, try drawing directly with a coloured pencil.

Find out the scope of a particular pencil by testing it out in the way shown in illustration **2** below. Make some dots and dashes as well as different line effects, hatching and blended tone. See what sort of range you can achieve with your pencil from light to very dark. How does it respond to different sorts of paper? Establish some confidence in handling the pencil in this way before trying out some of the ideas on the next double-page.

A single pencil is capable of a wide variety

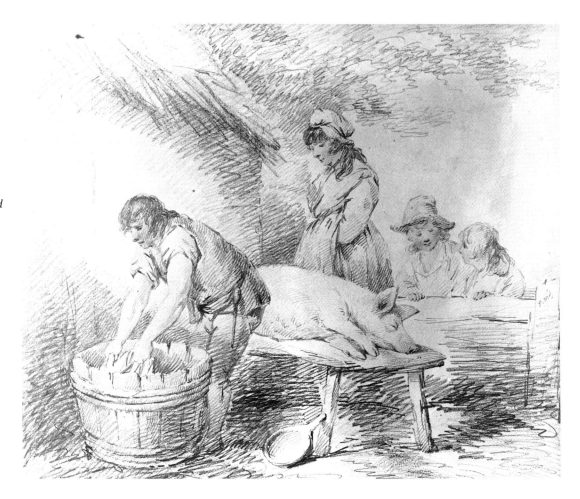

2 Killing the Pig, *by George Morland. Chalk and pencil drawing. Blackburn Museum and Art Gallery*

3 (a) *HB drawing pencil,*
(b) *3B drawing pencil,*
(c) *carpenter's pencil,*
(d) *graphite stick,*
(e) *propelling pencil,*
(f) *coloured pencil,*
(g) *water-soluble pencil*

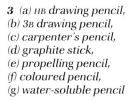

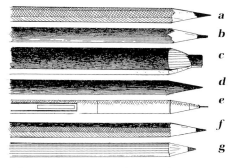

4 (Far right) *Marks made with pencil types (a)–(g)*

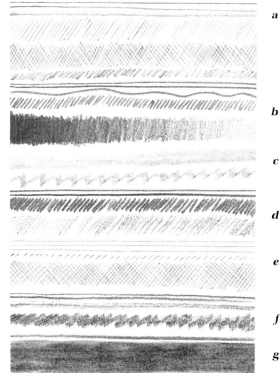

of marks if you simply vary the amount of pressure used. Sometimes though, you may need to combine several types of pencil to create a good range of tones and effects.

In any drawing an important factor is the choice of paper. Pencils act in different ways on different paper surfaces. A heavy textured paper, for example, will inhibit intricate detailed work, although it will help with soft shading techniques. Good quality cartridge paper (136 gsm) is suitable for most techniques, but try working on smooth paper, such as layout paper, or some really heavy quality watercolour paper to create a different response.

Soft pencils (2B or 3B) are ideal for line drawings. The sort of drawing shown below is a good way to build up confidence with the medium and to develop drawing skills generally.

Try drawing a chair or a similar object using just lines. Draw from direct observation and, to begin with, concentrate on outlines only. Use whatever pressure on the pencil seems natural and draw the shapes in monotone line without any variation of light and dark.

Now progress to lines that vary in strength, as in my drawing **1**. Draw the chair again, this time using darker, thicker lines for edges that are nearer, or are in shadow, or for some other reason need emphasis. Use less pressure, and consequently weaker lines, for distant edges. Compare your two drawings. Which one gives the best three-dimensional effect? Why?

You can develop this idea of creating a three-dimensional effect by using more lines, as in the saucepan drawing **2**. As before, a single 2B pencil will give plenty of scope for lines of various thickness and intensity, but if you think it necessary then use two or three different types of pencil.

Aim for plenty of contrast and exaggerate what you see so that nearer edges are emphasized with bold dark lines and the distant edges with soft, weak ones. Faint lines spaced well apart will give the effect of light shadows, whilst for more intense tones use a series of heavy lines close together.

Soft pencil is one of the best media for creating chiaroscuro (light and dark) effects in a drawing. Use a good quality 3B drawing pencil, or a softer pencil for large drawings, and build up the strength of shading gradually. Look at my other version of the saucepan (illustration **3**) to see how heavy tones are built up in several layers, with each layer worked in a different direction. You can use a putty eraser, a piece of cotton wool, a paper stump or a finger to work into areas of soft shading to fade and blend as required.

Have a look at **Light and dark** (pp. 34–5)

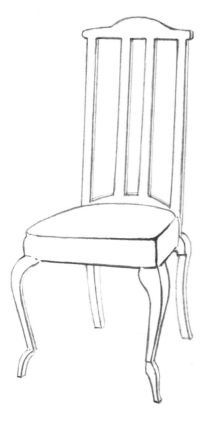

1

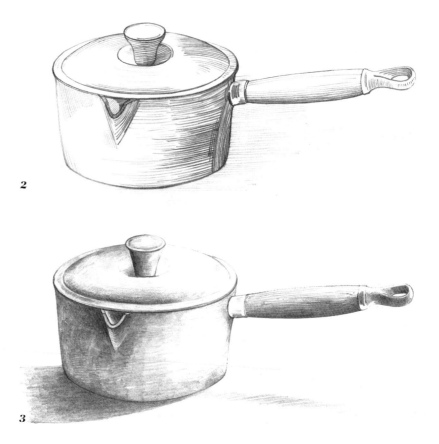

2

3

and **Shading techniques** (pp. 36–7) to help you develop this sort of work further.

Don't be afraid to try out coloured pencils! In fact, some subjects look better in colour, and this is a particularly good technique for small, detailed drawings and for adding sharp lines and definition to larger drawings in pastel and wash. Look at the colour drawings on pp. 58, 59, 63, 75, 82, 83 and 86.

Coloured pencils are usually hard and therefore the range of tones and breadth of techniques they can be adapted to are limited. Keep the pencil sharp and where possible use a short line hatching technique, (using short strokes at an angle), as shown in the tomato drawing **4**. For light, shaded areas I held the pencil so that the side of the lead could be used. For the very lightest areas (highlights) simply make use of the white of the paper. You can see that more intense tones need several layers of colour. Once again you need to make use of variations of colour, using light pressure to interblend different colours.

Water-soluble pencils can be used like coloured pencils but have the advantage that, if wetted with a clean brush, they can easily be blended or used to give wash and watercolour effects.

The drawing of *Cedars* by John Varley (illustration **5**) shows what a fine, sensitive medium pencil is for location drawings, as well as highly worked studio ones. The delicacy of touch and the scope for individual expression is without equal in any other drawing medium.

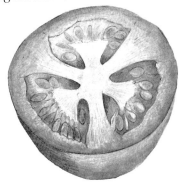

4

5 Cedars, *by John Varley, Pencil drawing. Glynn Vivian Art Gallery, Swansea*

Charcoal

Made from charred willow sticks, charcoal is one of the oldest drawing media, and dates back to the earliest cave dwellers. Willow rods are specially grown for charcoal; once cut, they are fired in a kiln until the wood is carbonized. The sticks vary in length and thickness from delicate ones to thick scene-painters' charcoal. The medium is also available in pencil form in soft, medium and hard degrees.

1

See what lines, marks and shading techniques are possible by experimenting with a stick of charcoal on some different types of paper, like illustration **2** below.

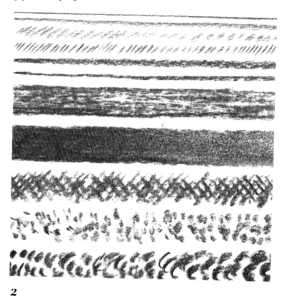

2

Charcoal sticks are generally quite brittle, so don't expect them to stand up to a lot of pressure. To draw in a linear way, hold the stick like a pencil. At an angle of about 45 degrees just the edge of the end of the stick will contact the paper, and will produce quite fine lines. If you hold the stick in a more vertical position, you will get thicker lines. You can wear the end down to more of a point by rubbing it on a piece of scrap paper. The charcoal stick will respond to delicate pressure and can produce some very subtle effects. Snap off a length of charcoal about 3 cm (1¼ in) long and use this on its side for more general shading effects.

To introduce yourself to charcoal drawing choose a subject like my seated figure **3**, or perhaps a building or household object. Try to draw this with just flat areas of tone. Use smooth paper, such as thin cartridge paper,

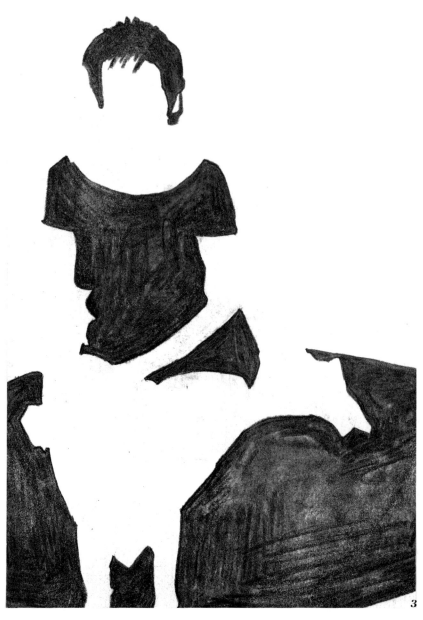

3

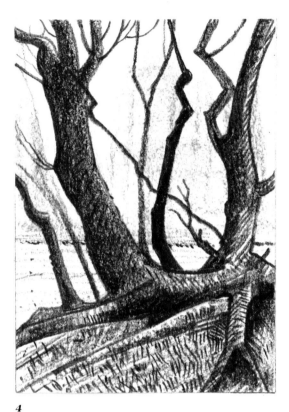

4

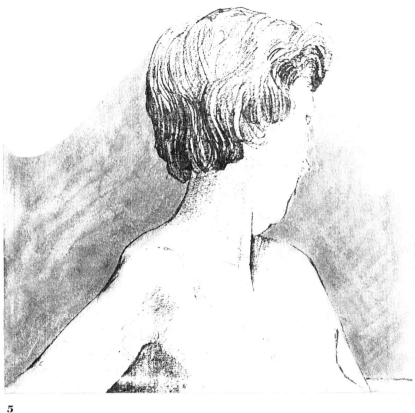

5

bank paper, newsprint or smooth card, so that you can make the tone quite even. With large areas, draw carefully round the edge first and then fill in. Use a series of soft, hatched lines. Blend these together by rubbing them with your finger or a small piece of paper or cotton wool. Blow away the surplus charcoal dust and clean up edges and white areas with a putty rubber.

Charcoal is a fast drawing method, ideal for sketchbook work. Tones and shadows can be set down rapidly. Aim to use this medium with fluency and feeling.

For more intricate studies use a selection of charcoal sticks of different thicknesses combined with a charcoal pencil for crisp lines and details. Work on heavier quality paper that will 'hold' the charcoal better, or try coloured pastel or sugar paper.

For a drawing like the tree (illustration **4**), lightly sketch in the main shapes first, using a thin charcoal stick or charcoal pencil. Work in the main background tones before building up the more positive and detailed areas of the

foreground. If possible, work from the top of the drawing downwards to avoid smudging the soft charcoal lines.

The soft tones of charcoal make it a good medium for life drawing (illustration **5**) and other studies where subtle chiaroscuro (light and dark) effects are required. Apply very light coatings of charcoal, working these into the paper surface. You can use a soft eraser or putty rubber to reduce tones that are too heavy, and to create highlights.

Try an *offsetting* method to make other delicate tones. To do this, rub some charcoal on a scrap sheet of paper and then dip a finger, a piece of cotton wool or cotton bud into this, before gently applying it to the selected area of the drawing.

Charcoal combines well with soft pencil drawing and is particularly effective for general background tones. Charcoal drawings easily smudge, so don't forget to spray them with fixative (*see* p. 23).

Pastels and chalks

Pastels are good for quick, expressive methods of drawing, especially for colour notes and sketchbook work. They are made from dry pigment bound with gum arabic. They are not expensive, so it's well worth buying a box to add to your range of media and techniques.

Coloured chalks respond in a similar way to pastels. Two types are available: dust-free and moulded. The softer, moulded chalks are best for drawing.

Also available are pastel pencils. You can sharpen these and use them like other pencils, but being soft they need treating with more care. Use them for adding lines and details to pastel drawings.

Oil pastels behave rather differently. They are made from a mixture of pigment, waxes and animal fat and are used in a similar way to wax crayons. Oil pastels will give more intense colours but cannot be smudged and blended like soft pastels and chalks.

1

The best way to get the 'feel' of pastel is to take a single colour and try out various lines, marks and solid tones on a sheet of paper, like illustration **2**. Feel free to experiment, but notice which effects work best. Use a large sheet of pastel paper, sugar paper or a similar paper with a slightly rough surface. Try colour and toned papers as well as off-white. Try these techniques:

- Hold the pastel stick at an angle so that just the slightest edge catches the paper to create thin lines and hatching effects. Square-section pastels are best for this. Alternatively, carefully sharpen the pastel stick with a sharp blade or some glasspaper to create more of a drawing point.

- Use a small length of pastel on its side to try out general shading. To make a heavy tone

either press harder on the crayon or use several layers of shading. Try smudging and fading out edges in various ways.

Oil pastels will produce rich, solid areas of colour on smooth paper, and broken, textured effects on paper with a heavy or rough surface. Once again, the best way of gaining some confidence with the medium is to try it out on some scraps of paper to find out what is possible (*see* illustration **3**).

2

3

Although you cannot smudge and blend oil pastels in the same way as soft pastels and chalks, you can soften and fade them by applying a thin wash of white spirit. They will respond to variations of touch and pressure, and you can interblend colours by an alternating hatching technique or by superimposing one colour over another.

Soft pastels were used for the flower drawing **4**. Try a similar drawing and start by lightly sketching in the main shapes, using an appropriate colour. Block in these main

shapes with general tones and colours before working over them with finer lines of detail, perhaps also using a pastel pencil. Use thin shadings of pastel, for it is always easier to add more rather than remove any surplus. Also, work on a coloured paper: it will help give some body to the pastel drawing, yet at the same time provide sufficient contrast to give impact.

Mix colours, either by alternating a line of one colour with another (a linear method), or by shading into an area of one colour with a second. With both techniques you can use either a piece of paper or your fingers to blend colours together. Blow away unwanted pastel dust and 'lift' mistakes with a putty rubber. The final drawing should be fixed to prevent smudging (*see* p. 22).

Many well known artists have used chalk and pastel techniques. Red and black chalk drawings were popular in Renaissance times, and later Latour and Chardin used pastels extensively for portraiture. Degas showed how pastel could be combined with other media, such as thinned oil paint and watercolour.

Look at illustration **5**, and note the delicacy of touch and restrained use of technique in this marvellous chalk study by François Boucher.

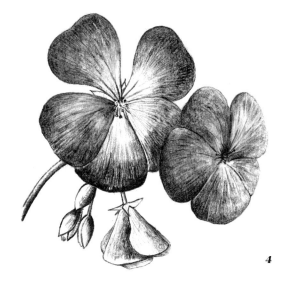

4

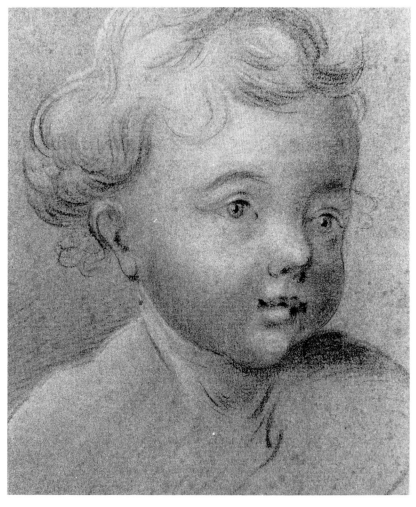

5 Boy's Head, *by François Boucher. Chalk. Glynn Vivian Art Gallery, Swansea*

Crayons

Remember those childhood drawings in wax crayon? Perhaps because of those passionate scribbles on the wall (and maybe more so because of the consequent reprimand!), we never really think of the wax crayon as a sensitive drawing medium. Yet it is capable of a very wide range of effects.

Wax crayons are available in standard and chunky varieties. You can sharpen and maintain a point on the standard crayons, allowing a variety of line and shading effects. The thicker crayons are useful for rubbings and resist techniques (painting over wax with watercolour; *see* p. 38).

Conté crayon is a hard, grease-free drawing chalk that is usually applied to coarse paper. It is not easily smudged but will give sensitive lines as well as quite dramatic qualities of tone. Conté drawing pencils are also available.

Make a small experiment like illustration **2** on the right. Use the sharp edge of a Conté crayon to make thin lines and hatching effects, and a short length on its side for more general shading, building up intense tones by means of greater pressure or with several layers. Try shading with a short length of Conté over some heavy quality watercolour paper to create a texture effect in your drawing (*see* illustration **3**).

You will notice from illustration **4** that wax crayons respond in a similar way to Conté crayon except that it is not possible to achieve the same depth of tone. A characteristic of both media is that it is difficult to shade solidly, so that always some of the white paper breaks through.

You can produce a broken-texture effect by shading heavily with a wax crayon and then applying a thin wash of watercolour or diluted ink, as in illustration **5**. Such textures make interesting backgrounds or can be used for particular effects like water or skies. When the wash is dry you can work over it with other ink or crayon techniques.

Another way of creating an area of texture in a drawing is to take a rubbing. You will find many surfaces around you which will give interesting rubbings: wood grain, frosted glass, metal grilles, and so on (*see* illustration **6**). To take a rubbing, cover the textured surface with a sheet of thin paper and hold

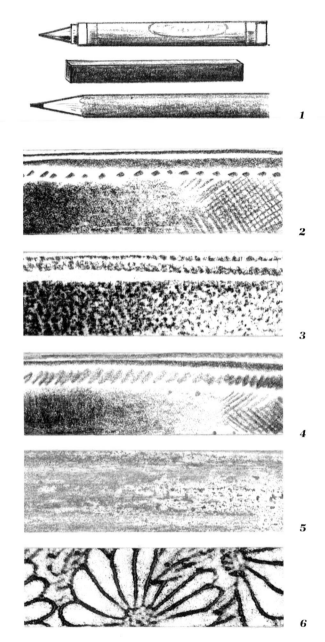

this firmly in place whilst the crayon is rubbed systematically across it. Use the crayon on its side and apply the pressure gradually, rubbing in one direction then another.

Now try out some quick on-the-spot drawings in your sketchbook like the landscape view in illustration **7**. I used a black wax crayon for this drawing, but Conté crayon will work in a similar way.

Neither medium is easily erased and so, like oil pastels, you need to work in a positive and direct way. Remember the points about varying the pressure, and using the thin end of the crayon as well as the side, in order to get different effects. These crayons have a limited tonal range so try combining them with some soft pencil lines to get some stronger tones.

A wax etching, like the bird **8** (*below*), is fun to make. Work on thick cartridge paper and start by covering the whole area with small patches of thick, coloured wax crayon (not black). Keep the drawing fairly small, say 205 × 155 mm (8 × 6 in). Then coat the waxed paper with a covering of undiluted Indian ink. The wax will do its best to resist the ink, so keep brushing until it finally submits! Aim for a thin, even coating. Leave to dry thoroughly.

Now make your drawing by using a sharp-pointed instrument to scratch through the ink. Use a nail, compass point, steel pin or something similar. The work is essentially linear, with the colours showing through where the ink has been scratched away.

You can make a similar drawing to this by coating the coloured paper with a layer of black wax instead of ink. This technique is called *sgraffito*.

Now have a look at the Henry Moore drawing **9** (*below*). Although he is best remembered for his magnificent and innovative sculptures, Moore was also a fine draughtsman, using a variety of media and techniques. In the drawings he made during the early 1940s of underground air raid shelters and coal mines, he used a lot of crayon texture and resist techniques, as in this example. Look at the dramatic use of tone in this drawing and at the way the crayon lines and textures have livened up the different surfaces. You can use Conté crayon, soft pencil crayon and graphite stick to give similar dramatic light and dark effects, though without the added interest of chance texture.

7 (*Above*) **8** (*Below*)

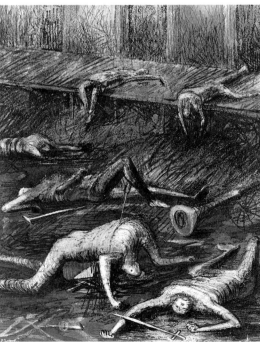

9 Death of the Suitors *by Henry Moore. Black chalk and wash drawing. Cecil Higgins Art Gallery, Bedford*

Pens

Illustration **1** shows that there are quite a number of different pens that you can use for drawing. Each type of pen will give a certain character of line and range of techniques. For drawings where you need real control and accuracy, a reservoir pen (such as a fountain pen, technical drawing pen or even a good ball-point pen) will be best. On the other hand, some people prefer the slightly unpredictable quality of the dip pen, which gives scope for drawings of greater personality. Van Gogh, for example, preferred the traditional reed pen.

Dip pens (such as mapping pens and script pens) are used with Indian ink, other coloured drawing inks, or even fountain-pen ink. Drawing inks are obtainable in waterproof or non-waterproof varieties. Waterproof ink dries quickly and permanently; once dry it cannot be wetted or altered in any way. Black Indian ink is the most useful for drawings, since it can be diluted with water to create lighter tones. Other pens have a built-in supply of ink, often from a replaceable cartridge or refillable reservoir. The following pens are worth trying out:

- *Mapping pens* These are inexpensive and usually consist of a wooden holder and interchangeable steel nib. They are good for small drawings and fine linear work. If cleaned regularly and not used with excessive pressure they will last a long time.

- *Script pens* These also consist of a holder and nib, but with a range of nib widths available the scope for line techniques is increased.

- *Technical pens* You can make meticulous line, detail and illustration work with these. They give a continuous flow of ink through a range of interchangeable, fine points.

- *Fountain pens* Use permanent black fountain-pen ink and select whatever nib you find suitable. In fact, similar pens with a slightly different nib are marketed as drawing pens.

- *Ball-point pens* Use these for sketchbook work. Good quality pens will in fact give quite subtle drawing effects.

- *Fibre-point and felt-tip pens* These are handy for general sketching and good for 'point' techniques. They are not suitable for good finished drawings because the ink discolours in time.

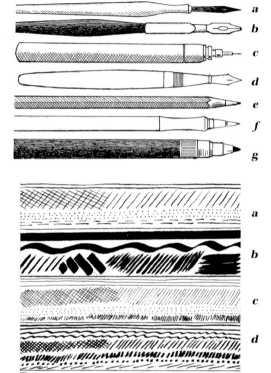

1 *(a) mapping pen, (b) script pen, (c) technical drawing pen, (d) fountain pen, (e) ball-point pen, (f) fibre-tip pen, (g) felt pen*

2 *Pen line techniques (a)–(g)*

Try out your pen on cartridge paper, smooth paper and coloured paper and see what it is capable of doing. See if you can make lines of different thicknesses and try out different tones and shading techniques. What happens when you vary the pressure on the pen or use the pen in a different direction?

The lines and marks in illustration **2** were made with the range of pens shown in illustration **1** and used in the same sequence. The drawing in illustration **3** was made with a

mapping pen. Try out this technique for yourself – choose a more passive subject if you wish, perhaps a plant, part of the garden, or the façade of a building.

Start by making a light pencil sketch to help you sort out the main shapes – you can rub out any unwanted pencil lines later. Develop the drawing with various types of lines. You can create darker areas and shadows by using hatched lines, scribbling or building up several layers of lines. The type of line will depend on the pen you choose. Differences in touch and pressure will give lines of different quality and strength.

Reservoir and cartridge pens are unlikely to make unwanted blobs; dip pens will also behave themselves quite well if you avoid overloading them with ink or applying too much pressure. Blotches, blobs and lines in the wrong place usually have to be worked into the drawing. Sometimes you can erase lines with a liquid ink eradicator, an ink eraser or correction fluid, though these tend to discolour or roughen up the paper surface.

As you gain confidence you can try

3

combining pen techniques with wash and pencil work.

With any medium you are not familiar with it is always worth looking at some examples by well-known artists. In illustration **4**, for example, look at the marvellous, sensitive and varied use of ink line by Van Gogh. Notice how he has used the direction of lines to suit different surfaces and give an indication of form and dimension. More intense tones are achieved by using lines very close together, by a cross-hatching technique, or simply by applying more pressure to the pen.

4 Thatched Roofs, *by Vincent Van Gogh. Reed pen.* Tate Gallery, London

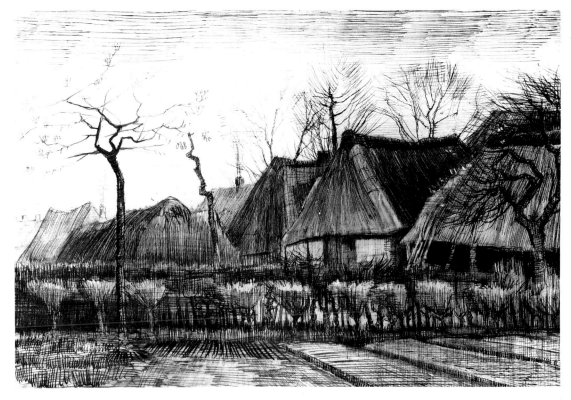

Brush and ink

You can draw directly with a brush dipped in ink or, alternatively, you can use diluted washes of ink, applied with a brush, as general tones to work over in more detail in pen or pencil.

It is worth buying good quality brushes. Although sable brushes are expensive, they will last a long time if treated with care. For drawing fine lines and for direct drawing with a brush use a fine (No. 2), pointed watercolour brush. You will find that short stippling brushes are useful for applying areas of texture or light tone to a drawing. Have a 15 mm (½ in) or 25 mm (1 in) household paintbrush handy for general wash techniques.

As with pen and ink, use Indian ink and coloured drawing inks. You can dilute the ink for stipple and wash effects. To make weaker colours fill a shallow container with water and add just a few drops of ink. In particular you will find that Indian ink is very strong and needs a lot of water to dilute it adequately.

Make a test piece like the one in illustration **2** to try out various brush drawing effects. Start by using a fine, soft brush and drawing some straight lines across the paper. Try varying the pressure on the brush so that you get thin and thick lines. Try out some other lines, curved, hatched and so on, as well as dots and dashes. Use a round, stiff-haired hog brush (No. 10), with very little ink on it, to make texture and stipple effects. Hold the brush in the normal way and drag it slowly across the paper to create a sort of broken texture effect. Hold it vertically and dab it gently up and down to produce a stippled area. Find out what happens when you draw with a brush over dampened paper or paper that has been coated with white wax crayon or a wash of white spirit.

Because of the nature of the technique, brush drawings need to be done in a more lively and energetic way than those using a pen. Start by making some observation drawings like the one shown in illustration **3**. Use just black or a single colour of ink. Work on A3 sheets of paper (297 × 420 mm (11¾ × 16½ in)) so that you can get used to flowing brush lines. Concentrate on the main shapes and lines and use solid areas of tone sparingly.

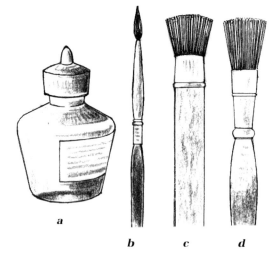

1 (a) drawing ink, (b) pointed sable brush, (c) stiff haired brush, (d) flat brush for wash techniques

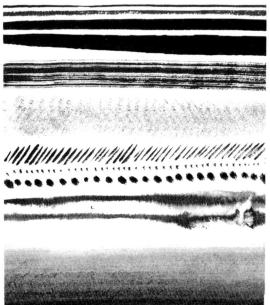

2

3

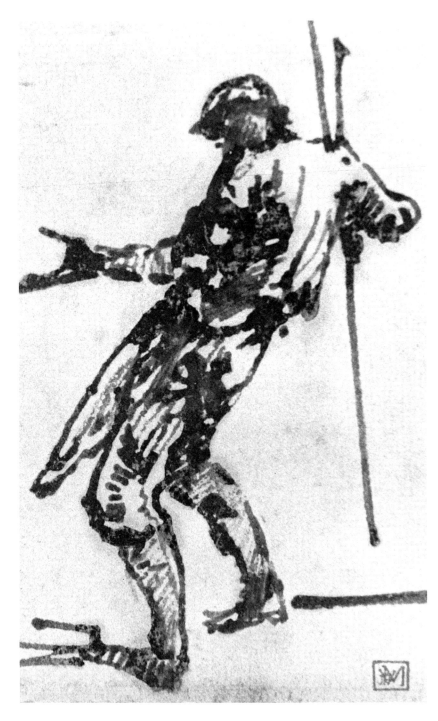

4 Venetian Study, *by Francesco Guardi. Ink wash.*
Glynn Vivian Art Gallery, Swansea

scrap paper first. If possible, use a separate brush for each tone, otherwise be sure to wipe the brush clean before dipping it in another tone.

Now you can progress to the sort of brush and wash drawing shown in illustration **5**. This uses thin tones of ink wash applied one over another to build up a three-dimensional effect. You can try two different methods. First, make a drawing in which each layer of wash is allowed to dry before you add the next; continue in this way until the required strength of tone is achieved. Then make a drawing in which the darker tones are worked into the weaker ones whilst the ink is still wet and therefore still able to be manipulated.

Work from light to dark in these drawings; always start with the weakest or lightest tones. Highlights should be left as the white of the paper. The whiteness will give a good contrast and help enhance the rest of the drawing. Fine details can be added with pen and ink or a sharp, dark pencil.

Often brush and wash drawings have a vigour and immediacy that is lacking with other techniques. Notice in drawing **4** above how Guardi has captured a feeling of life and action with a few swift brushstrokes.

Try a figure drawing of your own, setting yourself a time limit of five minutes so that you are not tempted to overwork the drawing. Use two or three different tones of ink by diluting it in the way described on the opposite page. Test out the tones on some

5

Other materials and equipment

The type of paper you use may well determine the success or failure of a drawing. If you are unsure about what to use then test the medium on various scrap papers or offcuts first.

The surface of the paper is known as the 'ground' or 'tooth' and can vary from very smooth to heavy quality, hand-made watercolour papers. Most papers are sized to produce a more receptive working surface, whilst others are treated with a coating of China clay and other chemicals to give the surface texture opacity. Sometimes such surfaces are polished or calendered to produce high grade art papers.

Paper is said to have a 'right' and a 'wrong' side. Of course, either side of the paper can be used, though for most drawings the correct side will be the one with the uneven surface, the reverse side being the one with the mechanical texture derived from the screen on which it was dried. To check the difference, hold the paper up to the light and bend over the corner. The light should show up the mechanical surface.

Suppliers indicate the thickness or quality of paper by stating its weight in grammes per square metre, thus cartridge paper of 125 gsm is of a thin quality, whilst that of 180 gsm will have a heavy texture. Sheet sizes are mostly standardized to ISO (International Organization for Standardization) paper sizes, the largest being A1 (594 × 841 mm) and the smallest A6 (105 × 148 mm). Some papers are still made to 'Royal' sizes (24 × 19 in) or 'Imperial' (30 × 22 in).

- Cartridge paper of various qualities will suit most drawings made in pencil, charcoal or Conté crayon.

- Thin, smooth papers like newsprint and duplicating paper will be fine for rubbings and some charcoal and chalk techniques.

- Illustration board and art paper can be used for pen and ink work.

- Sugar paper and pastel papers have a rougher surface, making them ideal for pastel and chalk drawings.

- Coloured papers are also useful for pastel, chalk and crayon techniques.

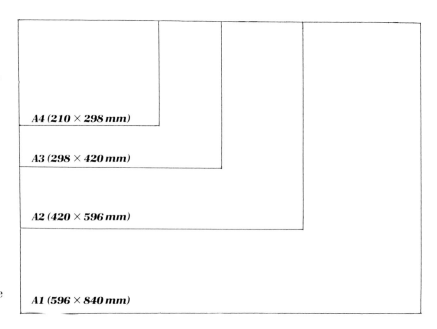

1 ISO paper sizes. Each size is exactly half the area of the next size

Check whether the paper needs stretching or preparing in some other way before you start work (*see* p. 68).

Choose the type of sketchbook that suits the media and techniques you have in mind. Generally an A4 cartridge sketchbook is best, whilst a pocket sketchpad is useful for the sort of quick sketches and notes you might jot down in ball-point pen or pencil.

A wedge-shaped eraser is fine for general pencil work, but for soft tone techniques (soft pencil, chalk and charcoal) use a kneaded or putty rubber. Breadcrumbs can also be used to erase lines. For fine highlights and delicate edges use a pencil-type typewriter rubber, or cut off a small piece from a wedge-shaped eraser. Keep the eraser clean by rubbing it on scrap paper.

Soft pencil, chalk, pastel and charcoal drawings will all need fixing when finished to prevent smudging. Fixative is a type of thin varnish and is available is aerosol cans, or bottles with spray diffusers. Spray in light coatings from a distance of about 25 cm (10 in). Be careful not to 'flood' delicate work and thus spoil it.

Always take proper precautions when using fixative. Use it only in a well-ventilated room; do not smoke, and keep the fixative away from all sources of ignition. It is a highly flammable substance that is harmful if inhaled or sprayed on skin.

A cheap metal blow-pipe hinged diffuser is useful for various ink and texture techniques. Make sure it is thoroughly cleaned after use (*see* pp. 30 and 38).

Although a small plastic or metal pencil sharpener is sometimes useful, in general a knife is best to sharpen pencils and other drawing media. Sharpen hard pencils and crayons by rubbing them on coarse glass-paper.

Paper stumps can be purchased from suppliers or made simply by tightly rolling a sheet of thin paper in such a way as to make a conical-shaped end. Paper stumps are very useful for working into charcoal, chalk, pastel and soft pencil, to fade out edges and create various tone effects.

You will need some board clips or pins to secure paper to a drawing board whilst you work on it.

In addition, you will find rulers and flexicurves useful for work that needs accurate straight and curved lines; a well palette is essential for mixing washes of ink; and a piece of sponge is handy for texture work. As you do more drawing you will find other odd items that help in the particular way you work. Equipment isn't always conventional!

So be prepared to try out some unusual drawing tools in addition to the obvious ones. You can draw with a bit of an old comb dipped in ink, for example, or apply a stipple effect with a toothbrush. Sometimes, chance techniques will work well and create an exciting starting point for a drawing. Look at illustration **9**. Most of this was made by blowing drops of ink across the paper with a drinking straw. Some detail was then added with a soft pencil.

2 *An A4 Spiral-bound sketch book*

3 *Wedge-shaped and putty erasers*

4 *Aerosol fixative*

5 *Spray diffuser*

6 *Pencil sharpener and craft knife*

7 *Paper stump*

8 *Drawing pins and board clip*

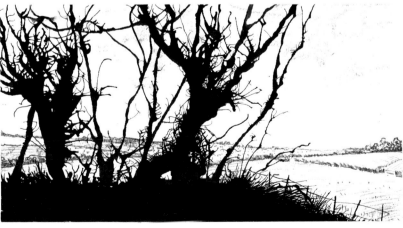

PRACTISING TECHNIQUES

Confidence in a range of techniques will add to the success of your drawing. A knowledge of different techniques will mean that you can select the best method for the subject matter and effect you want. For example, notice in illustration **1** (*below*) how Constable has successfully combined washes of tone for shadows and foliage with more delicate line drawing in pencil and crayon. The result is a lively, interesting and convincing drawing, the harmony of which is not spoilt by the combination of techniques.

Therefore, be prepared to experiment with a wide variety of methods. Look at the examples and information on the following pages and try out as many techniques as possible. Notice the characteristics of individual techniques and what sort of subject matter and effects they would best suit. Make as many experiments as you like. Don't be inhibited by thoughts of wasting time or paper. Keep such experiments for further reference, adding written notes to them if you wish.

The basic techniques of line, wash, tone and texture will be influenced by the medium

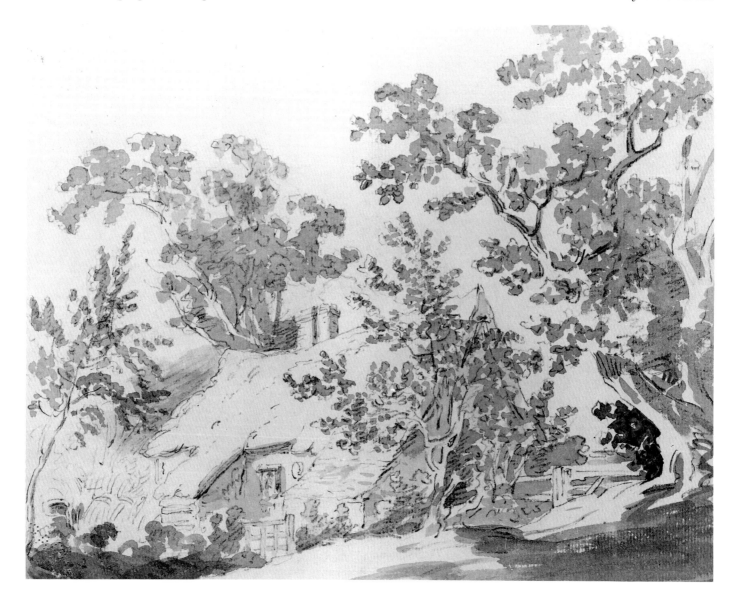

used and the surface to which they are applied. Test out each technique with a range of media and on different types of paper and card. Work in colour as well as black and white. Try some unconventional, as well as conventional, techniques. You can make a line drawing in sand or wet plaster, for example, just as you can on paper.

Using lines

You can use lines to show the shape of something, and for methods of shading, making textures and suggesting different surface effects. A line drawing can be a quick sketch or a highly detailed and sensitive study; it can be drawn free-hand or with a straight edge, template or other drawing aid.

Try drawing lines with as many different drawing tools and media as possible. In most cases, you can vary the pressure used or manipulate the medium in some way to make your lines thin, delicate and sensitive, or thick, bold and dominant. Get some ideas from illustration **2** (*below*). This also shows alternative ways of making lines, for example, offsetting lines with the edge of a piece of card

dipped in ink, and erasing lines from a shaded area using the sharp point of a rubber.

The economy of line in an outline drawing can be used to great effect. Look at the Michael Craig-Martin drawing (illustration **3**) to see how you can make contrasts between the strength (light and dark values) and the thickness of different lines. Try a still-life drawing of your own using this technique. Set up a group of household objects and draw them using different types of lines only. Try a second drawing in a different medium or perhaps using a more experimental technique.

Picasso, Matisse, Hockney, Klee and Miró are other artists who have produced many exciting line drawings. It is well worth trying to find some books on these artists in your local library, or look at some actual drawings in a gallery. Have a look also at the drawings on pp. 10 and 26.

1 (Left) A cottage after Sir George Beaumont, *by John Constable. Black crayon, pencil and monochrome wash. Royal Albert Memorial Museum, Exeter*

2 (Below) *Various types of line:* (a) *straight,* (b) *hatched,* (c) *wavy,* (d) *random,* (e) *offset,* (f) *erased*

3 (Below) Reading with a Globe (1980), *by Michael Craig-Martin. Tate Gallery, London*

a
b
c
d
e
f

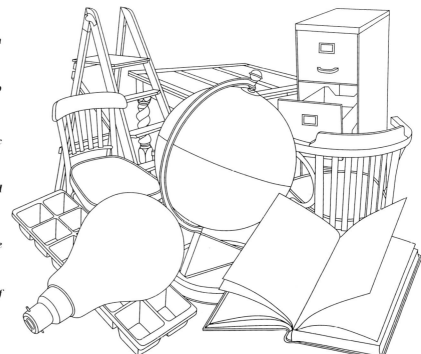

Line drawings

After some initial experiments with various types of line, try some small drawings in which a single line is repeated. Start with a simple abstract design like the one in illustration **1**. Use a sharp B pencil, fine fibre pen or technical pen. Vary the spacing between lines, but try to repeat the lines as accurately as possible. This will be good practice, both for drawing lines and for handling different drawing tools and media.

1

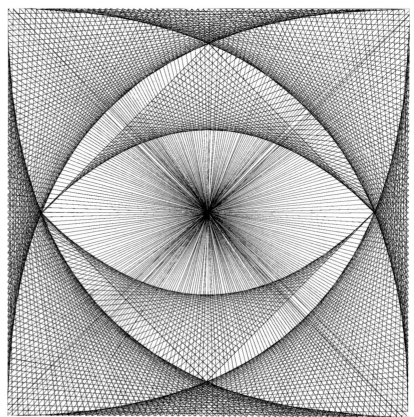

3　　　　　　　　*2*

Now try a drawing based on a number of specific shapes or objects, a still-life group, for example. Repeat the outlines, both inwards to fill the shapes, and outwards to fill the surrounding space. Again, vary the spacing between lines, and in this case experiment with the thickness of the line. Other drawings using repeated lines can be made with a card template or stencil.

Very effective optical and abstract results can be achieved by using carefully measured and ruled lines and joining them to a common point or points. A technical pen, such as a *Rotring* pen, is ideal for this. Start with a small square of paper, say 200 mm (8 in) square, and divide it along the edge at 5 mm (¼ in) intervals. Join these points to one or two other points placed at random somewhere towards the middle of the paper. You can then move on to more complex designs, like the one in illustration **2**.

For other drawings you can use straight, ruled lines in a stylized way, perhaps to produce a portrait or still-life. You could use a number of different drawing implements in order to vary the thickness and quality of the lines. In the example on the right, **3**, the line drawing has been made with a fine fibre pen over a preliminary drawing in weak pencil. Here, the strength and thickness of the line is

4

constant but the outline shapes have been subdivided, with the variety of shapes giving the drawing plenty of interest.

An obvious progression from this is to vary the weight of line in some parts to give contrast and emphasis. Stronger lines will attract more attention and make the shape stand out against its surroundings. Look also at the drawings on p. 10.

Line drawings can be produced by a variety of less conventional methods: from rubbings; from impressing lines into a surface; from offsetting with card and ink; and from various printmaking techniques. For an effect similar to the one shown in illustration **4**, first roll out a thin layer of printing ink on a glass slab. Lightly impress a length of string into the ink and cover with thin paper. Use a piece of cloth to press the paper down onto the ink, using a dabbing method. Then remove the paper to reveal the line drawing on the back. Other monoprint techniques can be made by drawing or scratching into the inked surface, or masking out with thin strips of paper.

A careful study or drawing made from observation like the one below, will need a variety of line techniques. Choose different line methods to interpret various textures, tones and details. Make the flow of your lines match the particular surface and give a suggestion of depth. You can build up tones by using closely-hatched and cross-hatched lines, whilst lighter areas use short, dashed lines, or lines spaced well apart.

Pens and pencils are the most suitable media for this kind of drawing. Often it is better to use several different pens or pencils to increase the possible range of tones and variation of lines. Have another look at the Van Gogh drawing on p. 19.

5

Dots and dashes

A drawing can be made up entirely of dots and dashes, or a dotting method used in some parts, with another technique in others. For example, since a dotting or point technique creates interesting medium tones and a particular sort of texture, it could be used for the sky area of a drawing in which other parts were treated with more solid tones in wash and pencil.

Illustration **1** shows a number of suitable drawing tools and the sorts of dots they produce. As an introduction to drawing with points try out as many of these implements as you can, to see for yourself what sort of dots they produce and some of the different tone and texture effects that are possible. Test out pencils and pens of different kinds, as well as offset point from dowel, fingers and brushes. Pens are the most reliable, especially free-flowing pens such as fibre and felt-tip, ball-point and technical pens. Notice the size of the dot produced from a particular implement and test out what sort of shading effects are possible. Hold the pencil or pen vertically and dab it up and down to produce the dotting effect. Try differences of pressure, but be careful not to damage the nib or point of the pen!

You can make larger and more intense dots by using an offsetting method. Take a short piece of thin dowel, the blunt end of a paint brush, or a round pencil, and dip it in a shallow quantity of ink or paint. Now press this down in the appropriate place on the drawing paper. Experience will show how much ink to use and how much pressure to apply.

Try an exercise like the one in illustration **2**, in which the spacing of dots is varied to produce light and dark effects. Use the dots close together to make an intense tone and space them further apart for lighter areas. With some experience it will be possible to create a gradual transition from dark to light.

Try out some other more unusual ways of making dots. Sometimes very interesting textures and effects can be achieved by unorthodox methods. Illustration **3** was made with a drinking straw dipped in ink.

As in illustration **4**, a drawing can be formed entirely of dots. Used side by side, the

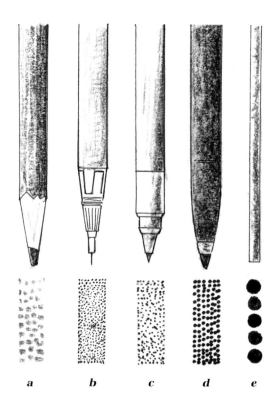

1 Dots with (a) soft pencil, (b) technical drawing pen, (c) fibre-point pen, (d) felt-tip pen, (e) offsetting from thin dowel

a b c d e

2

3

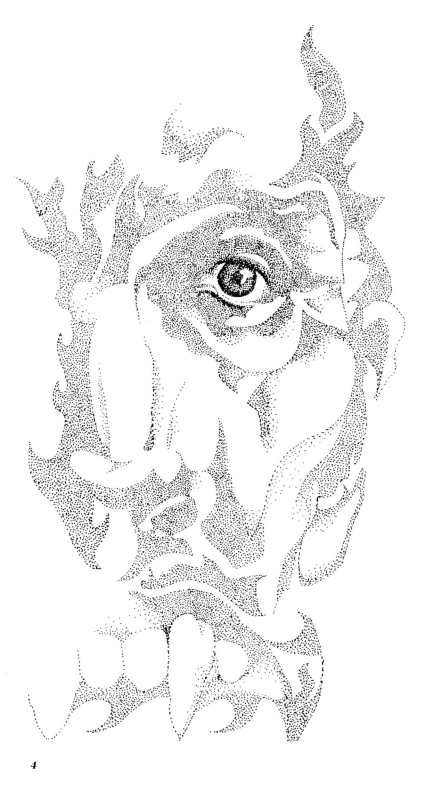

dots produce a broken line or outlining effect to give the drawing some structure. Variations of pressure and spacing can be applied to other areas to create different shading effects. The result is a more subtle and perhaps more interesting drawing than might be achieved by a line or line and tone method. However, it has to be said that making a drawing solely with point techniques can be a time-consuming and sometimes laborious process – but do try it!

Picasso, Matisse, Signac, Seurat and Van Gogh are some of the great artists who have used a *pointillist* (point or dot) technique in their work. Look at some of the paintings and crayon drawings by Seurat, for example, to see how atmosphere and light and dark can be achieved in this way. Van Gogh often combines point with line to make very lively and interesting drawings.

Point combines well with very short dashes or stabs of medium as in the pen and ink drawing below. The use of a few continuous lines will give a little contrast and help unite various parts of the drawing. Notice the use of strong contrasts of light and dark and how this has been achieved by using a close concentration of dots and dashes. Try a small landscape drawing of your own that uses these techniques.

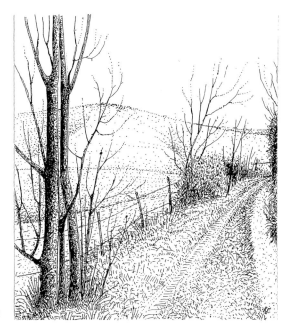

4

5

Spraying

You can use drawing inks, poster colour, gouache and watercolour paints for spraying techniques. Drawing ink is probably the most reliable: use it straight from the bottle or dilute it slightly with water. Experiment with mixtures of water-based paints, adding a little water at a time until you get the strength of colour you want. You can intermix colours with both inks and paints.

1 Ways of spraying: (a) ink and spray diffuser, (b) aerosol paint, (c) airbrush

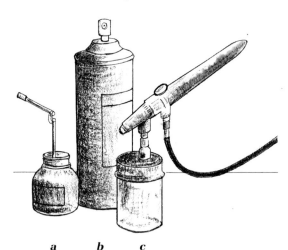

a b c

2

Apply the ink or paint spray with a metal diffuser (*see* p. 30) or an airbrush, or by using aerosol cans of paint. For most drawings the cheap diffuser is adequate. Although an airbrush is far more reliable and controllable, it is an expensive item of equipment and is probably not worth purchasing unless you are going to use it frequently.

Spraying is a good technique for creating interesting general textures in a drawing. You can spray the whole sheet of paper first and then work over it with various media, including pastels, inks and paints. Alternatively, you can use pieces of paper to mask out areas so that the spray can be confined to particular shapes.

Before you risk applying spray to a prized drawing, make a few test pieces. Illustration **2** shows three strengths of spray made with a spray diffuser and Indian ink. A diffuser works best with undiluted drawing ink. You will find that spraying from a greater distance will produce a finer, lighter spray, and closer to will give a more concentrated and intense tone. Build up darker tones with several coats of spray, allowing each to dry before re-spraying. Spray has an annoying habit of drifting a good distance, so remember to cover up the carpet and surrounding area with plenty of newspaper!

To confine the spray to a particular area of the drawing you will need to mask out the rest. To do this make a careful tracing of all the parts to be masked out – the parts you don't want to spray. Cut out the tracing very precisely and fix it in place on the drawing with very small pieces of *Blu-tack* so that only the parts to be sprayed are exposed. Apply the spray lightly, allowing it to dry before re-spraying, to build up the effect you require. Illustrations **3** and **4** show how the drawing looks with the paper mask or tracing in place before spraying, and with the masking removed, showing the sprayed background.

Whenever possible do any spraying first, before working on more detailed parts of the drawing. Most spraying techniques are quite easy to set up and produce and are quick to repeat if they go wrong. On the other hand, it is not so easy to reproduce an almost completed, detailed drawing in pen and ink should the addition of spray spoil it!

3

4

In illustration **5** (*below*), the foreground area and the moon were masked out with paper shapes before very light tones of Indian ink spray were applied to the sky. When dry, I worked over this with a mapping pen and ink to build up the detail of the drawing.

Try this technique for yourself. You could work in black and white, as I have done, or you could try using coloured ink spray, with the drawing developed using coloured pencils, inks, pastels or chalks. Instead of using a spray diffuser you could try light coatings of aerosol spray paint. These can also be overworked in ink, pencil, charcoal or chalks.

5

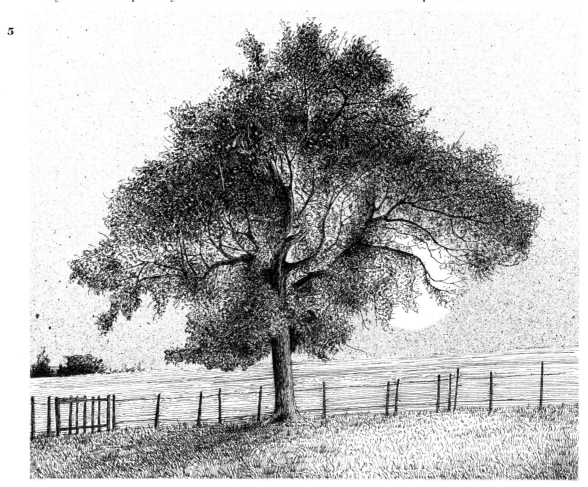

Wash

Wash is very thin ink or watercolour. You can make a complete drawing using brush and wash techniques or, like spraying, the wash can be applied as a background to work over with other media, or used for individual parts of a drawing to create a contrasting tone or texture.

Illustration **1** shows the three types of brush you will need: a large, flat brush for blocking in big areas with wash; a medium-sized (No. 8), pointed, sable brush for general tones; and a fine (No. 2) pointed sable for details. If you use drawing ink for making the wash, remember that once dry it becomes permanent, whilst a watercolour wash can be re-wetted, lifted off, or further manipulated. Work on paper of a reasonably absorbent character, such as good quality cartridge paper or watercolour paper.

Try mixing some different strengths of ink or paint wash and applying these as general background tones across a large sheet of paper. Use a well palette or similar shallow container in which to mix the wash. You will find that you will need only a few drops of ink or paint and quite a large quantity of water – otherwise the colours will be too strong.

With any area of wash work quickly to avoid the edges drying and creating 'tide marks' (uneven patches of colour). Use the largest brush possible. For large background washes tape the paper to a drawing board, or 'stretch' it in the way described on p. 68. Work from the top, applying the wash across the paper with quick, broad strokes of the brush, as shown in illustration **2**. Let the wash dry and see if you need to repaint it to make any parts stronger in colour.

Try an exercise like the one in the adjacent illustration **3**, in which you aim to blend several tones of wash together. You can blend tones or colours by working on damp paper, or by running several tones into each other whilst they are still wet, and then lightly brushing over them with a clean, wet brush to fade out any obvious edges.

Look at illustrations **4** and **5**. You can use wash as a general background tone, like the drawing on the left. Leave the white paper showing through if you want to suggest any highlights. Now you can work over the dried

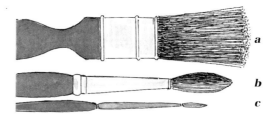

1 Brushes for applying wash: (a) flat, household paintbrush for large areas, (b) medium-sized sable brush for specific shapes, (c) fine, pointed sable brush for detailed work on edges

2

3

wash in pens or pencils, like the drawing on the right.

In a drawing in which wash is used as the main technique, like Ruskin's *View of Bologna* (*opposite*), start by laying in the general background tones and areas of wash. Add further layers of wash as necessary until you are satisfied with the basic distribution of tones. Now add some detail to the drawing, using more controlled areas of wash and lines applied with a fine brush. Where possible, work from background to foreground and from the top to the bottom of the paper.

Notice from Ruskin's drawing that this is not a technique to be fussed over, but rather one which needs spontaneity and lightness of touch. He has used the method to give a wonderful feeling of space, depth and dappled light in his drawing.

4

5

6 View of Bologna, *by John Ruskin. Sepia ink and wash. Tate Gallery, London*

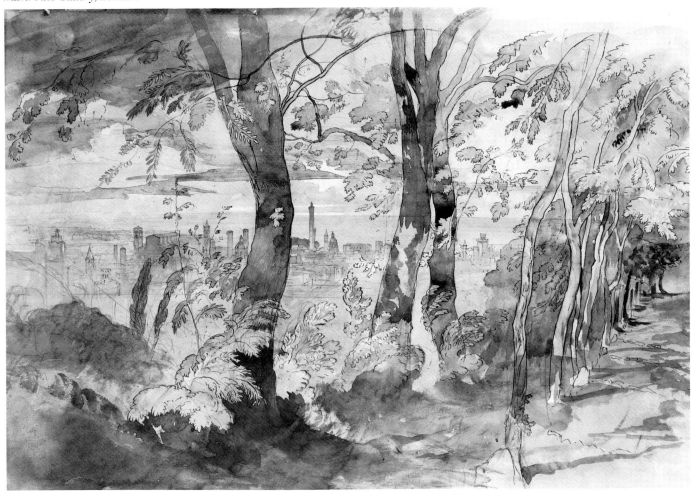

Light and dark

You need to use differences of tone (light and dark effects) in a drawing in order to give a three-dimensional effect. Variations in tone may also help to suggest the character of the subject. This means that some areas of the drawing need shading with different intensities of tone, whilst others may be weaker and left blank. You can apply tone by using the various shading methods shown in the next four pages, or in a linear way, as shown on pp. 10 and 36.

Before having a go at using tone yourself it is well worth looking at some good examples by established artists. Compare, for example, some drawings by Leonardo with the chalk studies of Gainsborough or the pencil drawings of Constable. Look at some Picasso crayon drawings, or the intense charcoal sketches by Käthe Kollwitz. Notice how these artists use tone in different ways and combine it effectively with other elements in the drawing. Take note also of the contrasting effects produced by different media. Have a look at some of the drawings by well-known artists shown in this book, especially those on pp. 2, 7, 11, 19, 24, 34, 52 and 80.

When you have to draw something from direct observation try to determine the source and direction of light. Spend some time looking at the subject and noticing the distribution of light and dark. Look at the subject through half-closed eyes to help you identify the main light and dark areas.

As an introduction to working in tone, try drawing a simple box shape set at an angle to the light, as in illustration **1**. Think in terms of three main tones: light (which can be the white of the paper); medium; and dark. Use a soft (2B) pencil. Then try drawing one or two other objects, such as a jug, a vase or a kettle. Place them in a strong light so that there are positive shadows.

A single medium may restrict the range of tones you can achieve. Make one or two small drawings, like the one in illustration **2**, to try out a combination of media, such as ink and pencil or ink and charcoal. Confine yourself to simple, flat areas of tone to begin with.

Get used to looking at shapes and noticing the main areas of tone. You will find that in many drawings you have to be selective in the

tones you use and simplify what you see. Generally you will need to aim for a good contrast of tones. This not only helps in creating the illusion of form and depth, but adds to the interest of the drawing as well. So you may need to exaggerate what is there, making lighter tones softer, and darker tones more pronounced.

Help yourself with this process of selecting and evaluating tones by making some objective drawings in which the tone is

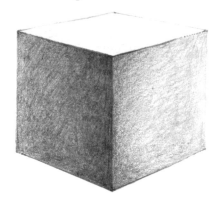

1

2

3

reduced to either light or dark, as in
illustration **3**. You can then develop this idea
through a series of drawings, adding to the
number of tones used.

Leonardo was the master of chiaroscuro
(light and dark effects) and sfumato (very
subtle blending from one tone to the next).
Notice in his chalk drawings (*below*) the
strong contrast between highlights and dark
tones. This not only produces a sense of form
but also gives great vitality to the drawing.

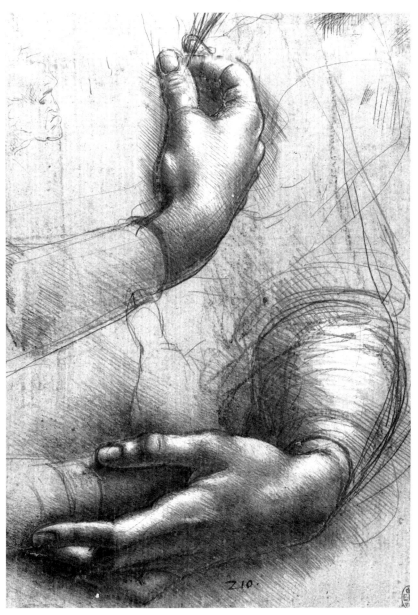

4 Study of Hands, *by Leonardo da Vinci. Chalk.
Windsor Castle, Royal Library, Her Majesty the
Queen*

Shading techniques

Methods of creating different tones will depend on the medium used. In general the 'softer' media, like pencil, charcoal, crayon and chalk, will provide the greatest scope. These media respond to slight variations of pressure and can be modified by using methods such as smudging, offsetting and erasure. With pen and ink and some other techniques, the actual tone may be constant.

Do an exercise like the one illustrated in **1** to test out a range of shading techniques using different media. Have a look back at some of the exercises and experiments recommended for different media in Section 1. Try out each medium with these methods of shading: using straight lines of different strengths; using hatched lines; smudging and fading; using solid tones of different intensities; and erasing.

Pens and pencils are good for linear methods of shading. Lines can vary in pressure (strength) and spacing to give the effect of a light tone (spaced apart) or intense tone (placed close together). Lines can also be hatched, that is, used in short strokes at an angle. Such shading can be covered by a layer of lines in the opposite direction, a method known as cross-hatching.

With a soft medium like 3B pencil, charcoal, chalk and pastel, you can make a blending from dark to light by smudging it with your finger, a piece of cloth or a paper stump. Try also using an eraser, especially a putty eraser, for fading tones and making highlights.

Make a drawing like the one in illustration **2** (*below*) to try out a range of pencils to make

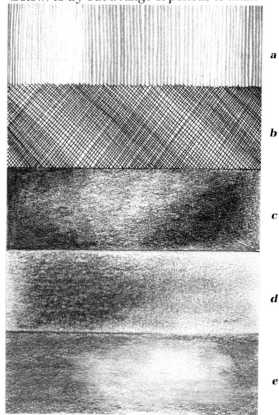

1 *Shading techniques: (a) lines, (b) cross-hatching, (c) soft pencil, (d) charcoal faded with a paper stump, (e) shading and erasing*

a

b

c

d

e

2

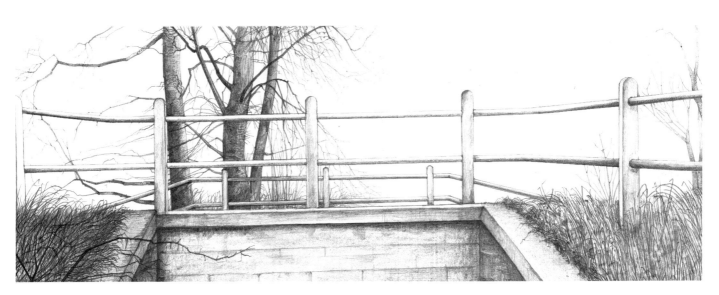

different tones. Choose a landscape, still-life or figure study. Soft pencils will give darker and more intense tones and are good for fading and blending. Use the lead on its side for really large areas and build up the strength of the tone gradually to avoid obvious pencil marks. Use sharp HB or H pencils for crisp lines and details.

The choice of medium is important not only because of the qualities of tone it can produce, but also in respect of other effects that show the essential characteristics of the subject. I chose soft pencil for the drawing of the tennis ball in illustration **3** because I thought it would suggest the texture of the surface as well as give me scope to make the object look spherical. Imagine how different it would look in ink.

As you gain experience with tonal effects and the use of different media, consider how the type of the paper might influence the drawing. You may require a very smooth paper for the subtle blending of tones; on the other hand, a coarse paper might help in achieving a particular texture or broken tone effect.

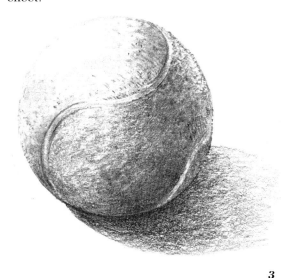

3

Sometimes a minimal reference to tone is enough. Look at the drawing by Pissarro (*right*). The experienced artist can give a totally convincing impression of form using just the merest indication of light and dark. Notice how changes in the strength of outlines alone can suggest tone.

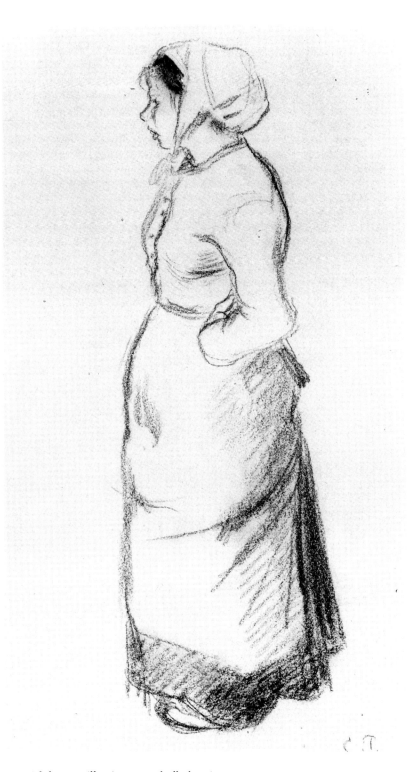

4 A Girl, *by Camille Pissarro. Chalk drawing.*
The National Museum of Wales, Cardiff

Texture

A drawing cannot have the same tactile qualities which might be found in a painting. It is seldom possible to build up actual impasto effects, so usually drawings have to give an *impression* of textures rather than actually creating them – a quality of vision rather than of touch.

But added texture can be an important aspect of a drawing. In an objective study it might be essential to use texture in some parts to suit the particular surfaces involved. Alternatively, an area of texture might be introduced as an interesting contrast to other drawing techniques.

If you want to incorporate texture in specific parts of a drawing it will need careful planning. Some textures are very controllable, whilst with others it may be necessary to mask out particular areas to prevent the texture running into other parts of the drawing. Sometimes a texture can be applied in a very general way as a background effect, and this worked over with more detailed drawing where necessary. Like spraying, it is often wise to attend to the textured areas first before developing the drawing in any detail. Think about the type of paper that will be most suitable and whether it will need stretching or preparing in some way before beginning work. Look at illustration **1** and try out the following ways of making texture:

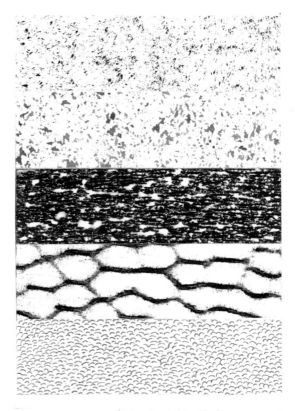

1

(a) *Stipple.* Use a stiff-haired brush or stippling brush dipped in a shallow quantity of ink or paint. Use only a little ink or paint on the brush. Hold the brush vertically and dab it up and down to produce the sort of mottled effect shown. Colours can be blended in this way or darker tones built up by further layers of stipple.

(b) *Sponge.* Use a small piece of sponge. Dip the sponge into some ink or paint and lightly press it down on to the drawing. This gives a more obvious, blotchy texture, but is less reliable than using stipple.

(c) *Resist.* Coat the paper with a thick layer of wax crayon. Paint over this with a wash of watercolour.

(d) *Rubbing.* Place the drawing paper over the selected textured surface and shade over

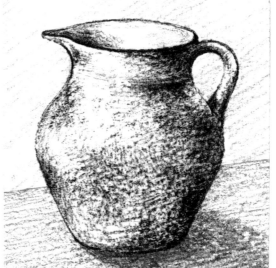

2

the area with wax crayon. Use a short length of wax on its side, gradually building up the pressure and hence the strength of the tone.

(e) *Pencil techniques.* Repeating dots, dashes and small marks like those illustrated can

give the impression of texture. Other drawing media can be used in a similar way.

Other techniques, such as spattering (flicking fairly dry paint from a bristle brush), spraying (*see* p. 30), and the use of point (*see* p. 28) will also produce textured effects. Try out all of these on some rough paper before using them in an actual drawing.

A good way of creating general textures is to use a coarse paper, such as heavy quality watercolour paper. Shade over this with a soft pencil, charcoal, pastel or chalk. The medium will only take to the upper part of the coarse fibres, so creating an open, mottled, broken tone effect, as in the charcoal and pencil

drawing in illustration **2**. But remember that with this type of paper it is not possible to make any areas of solid, smooth shading!

Some subjects lend themselves to a variety of texture effects (*see* illustration **3**). A combination of textures can give plenty of interest, contrast and character in a drawing. Try to select the texture techniques which suggest the different surfaces portrayed. My drawing uses pencil point for the sky, dashed pencil lines for the sea, wax resist overworked with pencil and ink for the beach, and stippling and soft pencil techniques for the cliffs. Because of the careful choice of techniques the drawing is more lively and successful.

3

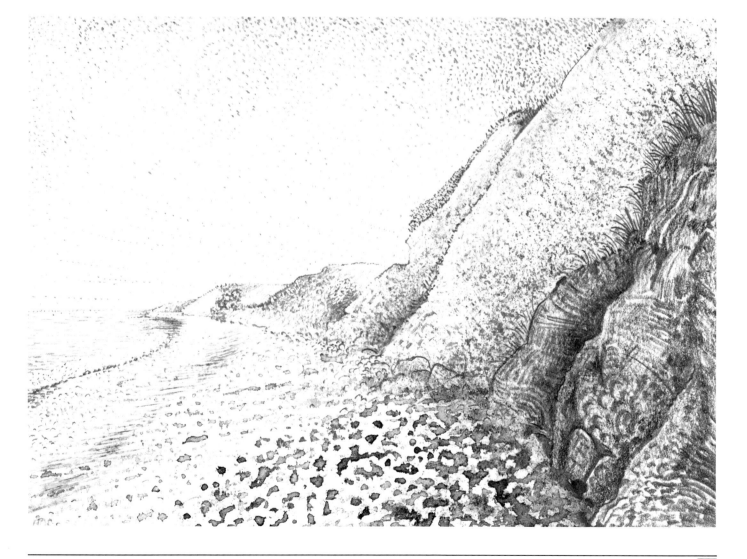

Combining techniques

Sometimes a single drawing technique is very effective and will be ideal for a particular subject. However, in order to achieve the range of tones and effects required in some drawings you will need to combine several techniques, and therefore probably also several media. Choose a range of techniques to suit the idea you have in mind. If you have any doubt about a technique then try it out on some scrap paper first. Consider how different media and techniques are going to work together and think about possible technical problems – for example, are they all going to work on the same type of paper?

The illustrations on these two pages show four versions of the same subject. Each drawing has involved a different combination of techniques. Notice how they vary. Each is successful, yet contrasting in the effect it gives. What some techniques lack in accuracy and detail, they compensate for in atmosphere and vitality. Like so many drawings, in the final analysis it is a question of subjective interpretation.

1

2

Illustration **1** uses mostly line and point techniques in pen and ink, with hatching and scribbling methods to suggest the texture of roofs and foliage. These techniques allow for sensitivity, accuracy and work in detail.

In illustration **2** I used thin washes of heavily diluted Indian ink for the main tones, applying several layers for the darker areas. I have used pencil lines and soft pencil shading to suggest textures and more subtle shadows, and made some lines with brush and ink to give emphasis in certain parts.

Various ink techniques were combined for illustration **3**: stipple, line, brush and wash. These methods were chosen to suit the different surfaces; they necessitate a broader treatment and the result is livelier and more spontaneous than the previous two illustrations.

Soft pencil, charcoal and charcoal pencil will give an interesting range of tones and techniques. Use stick charcoal for general areas and light tones, pencil for greyer tones and detail work, and charcoal pencil for textures, as in illustration **4**.

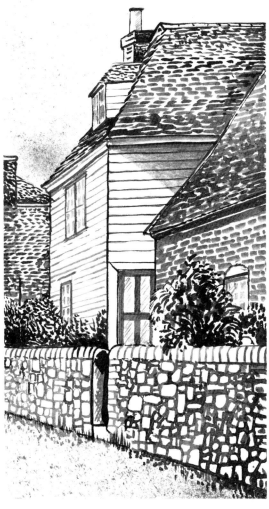

3

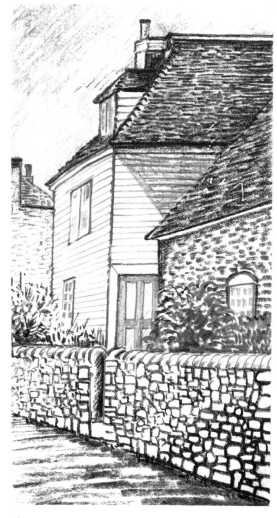

4

HOW TO DRAW SHAPES ACCURATELY

Although there are many different reasons for making a drawing, most drawings will need to be of a representational nature, aiming to show something exactly as you see it. Few people are blessed with a natural ability that means they can assess the shape and form of something at a glance and set it down accurately on paper without too much effort or reworking. Most of us need to adopt a methodical approach, working through a number of stages and making use of guide lines and other devices to help us construct shapes.

If the main shapes of the drawing are weak and poorly drawn then no matter how well it is developed and finished, and how good the use of media and techniques, the drawing will not be a total success. All drawings need a good underlying structure. For most, this will mean a series of well-drawn, accurately-constructed foundation shapes. These will give a sort of skeleton to which the flesh can be added, in the form of tone, texture and detail.

The pages in this section give you guidance and information on perspective, proportion and other general aspects, as well as showing you how to set about drawing a variety of everyday shapes. The advice and procedure given for the main subject areas illustrated can be applied equally successfully to many other topics.

1 (Left) *Isometric drawing*

2 (Right) *Perspective drawing*

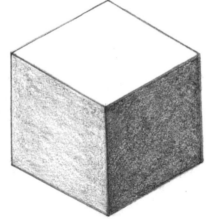

Perspective

In most of our drawings we are trying to create the illusion of depth, and perspective is one means of doing this. As draughtsmen, we need to understand the principles of perspective and how these influence what we draw. But remember that often perspective is used in conjunction with other devices, like proportion, tone and detail, to create the feeling of space and three-dimensional form. Drawings that rely solely on perspective will look artificial and mechanical. So get to understand the theory of perspective and be conscious of this as you draw, but don't overrate its importance – keep it in perspective!

If you stand on a bridge and look down a straight stretch of railway track into the

distance you will notice that the width of the track seems to get narrower, eventually fading away to a point on the horizon. Although you know that the sides of the track are parallel, you cannot draw them like that or they will seem to be going straight up in the air! So you must draw them *in perspective*. Perspective will apply to any straight or parallel lines in your drawing that are going back into the distance. Upright or vertical lines are normally unaffected.

Now look at illustrations **1** and **2** on the opposite page. In the first illustration I have drawn the cube as an isometric drawing, that is, with all of its edges the same length and with the top and bottom edges parallel. Notice that despite the shading, this cube still looks flat and unrealistic. In contrast, in illustration **2** I have made the sides of the

cube slope back, so that the top and bottom edges are getting nearer to each other the further they are extended. Like the railway track, the lines would eventually meet. Remember that in perspective parallel lines do meet if continued far enough.

The theory of this is shown in illustration **3**. Here the cube is shown from three different viewpoints, in each with the lines of the sides extended to show where they meet. The point where they meet is called the vanishing point, and this is on the horizon or eye level. Like these illustrations, most drawings use two-point perspective and have two vanishing points. VP stands for vanishing point, EL for eye level, and CV for centre of vision (the point on the horizon immediately opposite your eye).

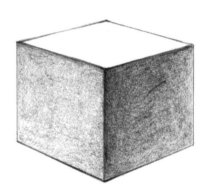

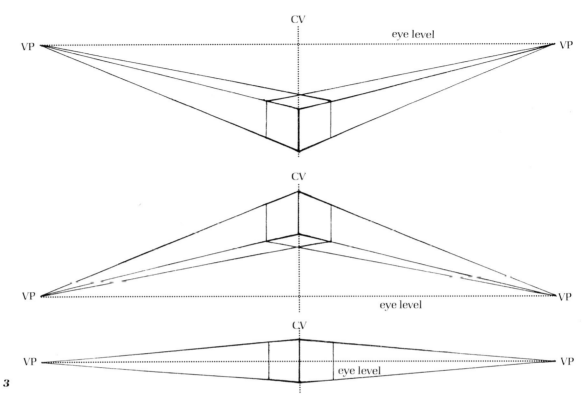

3

In most drawings what you are drawing will be quite close to you and you will want to make it fill the paper, so the lines of perspective, as in illustration **4** will extend well beyond the picture area. Take a simple box shape and try drawing it from all sorts of angles to test out the application of perspective, like my drawings in illustration **5**.

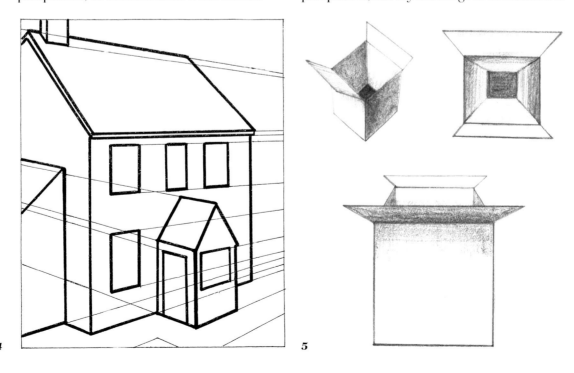

4

5

Size and scale

You can also suggest depth in a drawing by the way the size of one thing is related to another. Landscapes, for example, often use a human figure or two to set the scale of the scene and suggest distance. The great landscape artists of the seventeenth and eighteenth centuries modified the formal mathematical principles of perspective developed by their Renaissance predecessors, in favour of a more subtle illusion of space, achieved by contrasts of scale, colour and detail. The human figure is a size familiar to us and so when placed in the context of a picture it is easy to assess the size of other things in relation to it.

In illustration **1** below, the changing scale of the trees creates a great feeling of depth. Although I have used some perspective on the narrowing country lane, verges and hedgerows, particularly on the right, it is the obvious contrast in the size of the trees that emphasizes the sense of distance. We know that if they were placed side by side the trees would be roughly the same size, but as they get progressively smaller it implies a sense of distance. This device of repeating the same shape at different intervals in the drawing and with changing scale, is one that can often be used instead of, or in addition to, perspective.

Notice also how important tone (or colour) and detail are in supporting the illusion of depth. In general, try to emphasize nearer

1

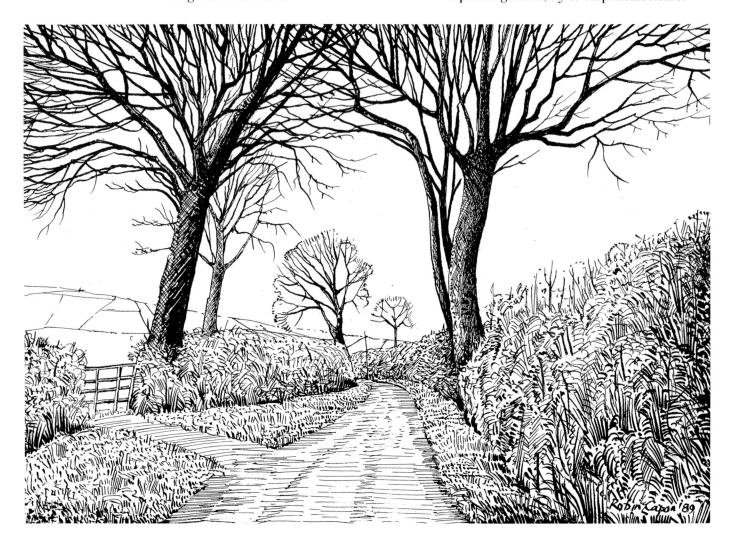

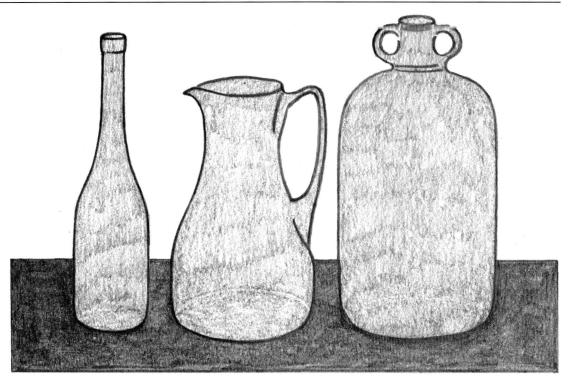

2

things with bolder tones or stronger colours and contrast the detailed foreground with a weaker and more general treatment of the distance.

Regard the edges of your paper as a kind of window frame through which you are looking into the drawing. This should help you work out the relative size of things. Objects that touch the bottom edge of the paper are obviously the nearest to you. All objects that are on the same base line (or horizontal line across the drawing), must be drawn in proportion to each other.

3

Look at illustrations **2** and **3** on this page. In the top illustration the objects are placed side by side and share a common base line – a horizontal line drawn through the centre of the base of one object, if continued, would run through the centre of the base of each of the others. Each object has some three-dimensional form and this could be developed with further variations of tone, but there is no real depth in this drawing. Compare the different sizes and shapes of the objects and notice how easy it would be to make comparative measurements across the paper to help draw the shapes in proportion to each other.

Now look at illustration **3**. Here, the same objects have been placed one behind the other. The scale and proportions have consequently changed and there is a much greater feeling of depth. The biggest object (on the right in the drawing above) is now drawn smaller than the others. This contrast in scale is often important in creating a sense of space and distance in your drawing.

Try a similar exercise of your own. Choose three objects varying in size and shape, placing the largest object on the right-hand side. Make two drawings like mine: one with the objects side-by-side, and one with them placed one behind the other. Concentrate on the size and shape of each object and look also at pp. 52 and 53 to help you draw these. Think about how the position of objects relative to one another affects their size, and consider this factor in any future drawings.

Faces

Start with a simple foundation or 'skeleton' sketch, like those shown in illustrations **1** and **2**. You can work in soft pencil, charcoal or chalks, but keep your initial lines faint so that they can easily be worked in with any subsequent tone and detail.

The position of the head is the first factor to consider. Check whether the head is facing you, is in profile (side view), or is at an angle to you (three-quarter view). Draw a rectangle, the proportions of which are based on the width and height of the head. Notice that this shape will vary from almost a square for the profile view to a rectangle in which the ratio of width to height is roughly 2:3. Now draw an oval or 'egg' shape within your rectangle, as shown in the illustrations. This will give you the general shape and proportions of the head.

Next, think about the position of the features. Draw a line half way down your 'egg-head'. Think of this like a sort of equator going round the earth – so it needs to be curved to follow the three-dimensional form of the head. Also draw a similarly curved line that goes from top to bottom half way across the head and runs straight down the middle of the nose. Notice the position of this line in my profile sketch **1** and three-quarter view **2**. All the features come in the lower half of the face, with the top of the eyes roughly on the half-way line. The space between the eyes is equivalent to the length of one eye, and the position of the bottom of the nose is almost half way down from eyes to chin. Mark in the position of all the features with lines as I have done in the sketches below.

Around these lines you can develop the precise shape of the features, also modifying the outline of the head to the particular characteristic of the hairline, brow, chin and jaw bone of your subject.

Keep any shading to a minimum, using just what is necessary to liven up the features and give the face some three-dimensional form. Look especially for the highlights on the cheek bones, nose, forehead and chin and the deeper shadows beneath eyes, nose, mouth and chin. Use a soft eraser to blend tones and

1

2

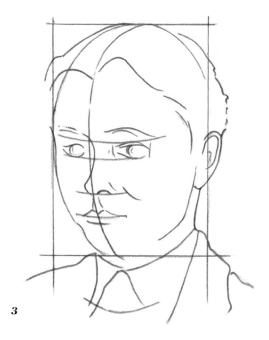

3

create highlights. See how these effects have been achieved in the striking portrait drawing by John Singer Sargent reproduced below.

Of course, my advice has been for drawing an average head – if such a thing exists! Every head varies in some way, so look carefully to find those distinct characteristics that help to create a real likeness (*see* also pp. 14, 67 and 73).

4 Harley Granville-Barker, *by John Singer Sargent. Chalk. National Portrait Gallery, London*

Figures

Think about the stance and proportions of the figure before attempting to add any real detail. As with drawing the head, you will find it helps to know something of the underlying anatomical structure. But failing any real knowledge of anatomy, get to know the basic proportions of the human figure, as shown in illustration **1**. Notice that the head is about one-eighth of the total height of the figure. Check the main points of reference, shown by the lines on the right-hand side of the illustration, in relation to the four equal divisions of the body, shown by the lines on the left. Practise drawing a few standing features of your own. Sketch in some guide lines first to help you get the right proportions. Get into the habit of using such guide lines whenever you draw figures.

Of course, most figures won't be standing rigidly upright in your drawing! They may be slumped in a chair or actually moving around! So check the pose and jot down a few lines to help you position the torso and limbs, as in illustration **2**. When you are satisfied with these positions you can add some flesh to the bare bones, as in the drawing on the right-hand side of the illustration.

2

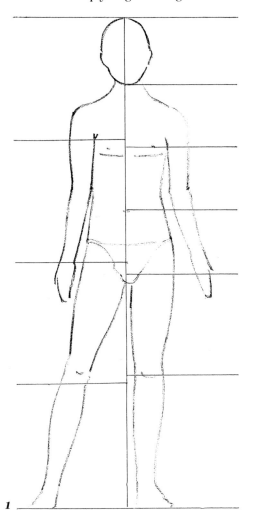

1

Clothed figures are often far more difficult to draw than nude ones. If you are able to work from a nude or mostly nude model then do so. To begin with, concentrate on the structure of the body and on the relative position and proportions of one part to another. Do plenty of quick, ten-minute sketches of different poses to help you plot out figures in this way and to develop some confidence. As with faces, use tone or colour in a restrained way, adding just enough to emphasize the form. You can do quick studies in charcoal, Conté crayons, pastels, soft pencil or brush and line. Try using colour, perhaps working on coloured paper of a contrasting tone.

The next stage is to try some details. You may have done some heads already, so look particularly at hands and feet, like the study shown in illustration **3**.

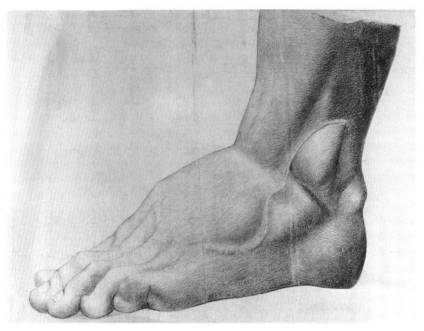

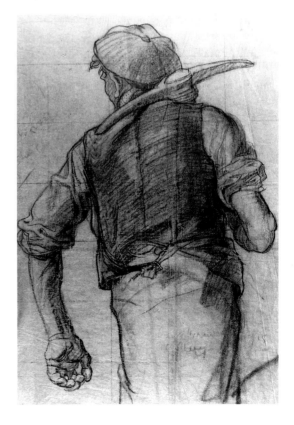

3 (Above) Sketch of a Foot, *by Frances Bally. Pencil. Williamson Art Gallery and Museum, Metropolitan Borough of Wirral*

4 (Above right) Kneeling Woman, *by John Constable. Pencil with wash. Royal Albert Memorial Museum, Exeter*

5 (Right) Miner, *by Frank Brangwyn. Black chalk. Blackburn Museum and Art Gallery*

With clothed figures, think about the underlying form of the body, and don't forget proportions! You can start with the two stages shown in illustration **2** and add clothes! Generally speaking, don't get too involved with folds and creases in clothing as these can detract from the basic shapes beneath. Look at the figure sketch by Constable in illustration **4** (*above*) and notice how the dress follows the form beneath. Take your sketchbook out into a busy high street, railway station or similar public place and try some quick sketches like this. Use a charcoal pencil or very soft pencil. Ignore details – concentrate on the flow of the overall shape. You may be able to work some of these sketches up into more detailed studies, like the powerful drawing of a *Coal Miner* by Frank Brangwyn, shown in illustration **5**. If not, get a friend to pose for you so that you can make some separate drawings like this.

I mentioned on p. 44 how figures can be used in a composition to set the scale and add a focal point of interest. This can be true of many types of landscape, imaginative and environmental compositions, so whenever you see an interesting character or pose jot it down in your pocket sketchbook!

Have a look also at the illustrations on pp. 6, 7, 13, 21, 35, 37, 78, 79 and 85.

Natural forms

Many natural forms have an obvious structure in the way that they have grown – think of a leaf, for example, or a tree, or a skull or a feather. Indeed, many such subjects have a symmetry and order not found elsewhere. So, once again, you are looking for the essential structure of the subject to give yourself a few key lines around which to build up the accurate shapes.

Most natural forms are small scale and will therefore be drawn at least life size, so careful observation is very important. Before you start any drawing, spend some minutes looking. Look in a critical and examining way. Notice not just the shape and structure of the object, but the colour, texture and detail. Decide what you think are the features which give the form its particular character. Jot those points down as notes or little sketches to act as a reminder when you are working on the final study. In fact, natural forms are ideal for analytical drawings – for making a series of drawings from different viewpoints, and showing as much accurately observed information as possible.

Start with some pencil studies. Use a B or 2B pencil to begin with, applying little pressure so that the lines are kept soft. These weak lines can easily be strengthened, or erased and altered, as the case may be. Work from simple shapes, like fruit or vegetables. Look at the size, outline shape, proportions and three-dimensional form of the subject and concentrate on these aspects. Use some simple guide lines to help you work out the shape, like those in illustration **1**. Do plenty of drawings – don't give up until you have mastered each form!

With some experience you can progress to more complicated subjects and try out various colour techniques. Soft pastels, coloured pencils, brush and wash techniques and coloured drawing inks are all suitable for these drawings. Try to suit the medium and technique to the character of the subject and the sort of effects you want. Soft pastels, for example, will work for subtle, blended tones, whilst you might choose a pencil hatching technique for a surface with an obvious texture. Also think about the strength of the colour you require. In my drawing of a

1

2

3

4

beetroot in illustration **2** I have used a colour wash to help give some 'body' to the colour and to suit the particular colouring and characteristics of this subject. I have worked over this wash with coloured pencils, using white pastel for the highlights.

Apply the same principles to a more complex study, like the plant drawing in **3** and **4**. In this case, start with the stem and give yourself some guide-lines to show the angle and direction of the leaves and flowers which grow out from this. Work out the outline shapes from this skeleton structure. If you are working in colour, keep your initial

pencil drawing weak so that you can work it in with the colour shading later on.

Illustration **3** shows the drawing sketched out in this way and some of the basic tones of colour applied. In this example the drawing is being worked in pastel and coloured pencils. When the foundation tones have been applied in pastel the details can be worked in using sharp coloured pencils, as in illustration **4**.

There are plenty of interesting natural forms around to have a go at. Look at pp. 82 and 83 for some other ideas and study the illustrations on pp. 8, 11, 32 and 72.

Objects

Mastering the sort of basic shapes shown on these two pages will mean that you can apply the procedure to more complex objects, especially those which may occur in a still-life composition.

Start with some easy box-type shapes. Look at illustration **1** and choose a similar box with flaps to draw. Begin with the main shape and add the flaps afterwards. First check the dimensions and proportions of the box – its height, width and length. Make some comparisons to help you estimate these proportions; the height may be twice the width, for example. Is the box at an angle to you? Sketch in the base of the box at what you consider to be the correct angle and from this make a freehand sketch of the whole shape. Think about perspective and how this will affect the parallel sides of the box. Have another look at p. 43 if you need to refresh your memory about this. When you are satisfied with the preliminary sketch you can use a straightedge to help you perfect the outline, although try not to rely too much on this sort of drawing aid.

Apply the same process to a box shape with legs, handles, wheels or any other additions. Ensure that the box part is correct first, and then add the extra bits, as in illustration **2** and in the evolution of the chair in illustrations **3** to **5**. Use whatever faint construction lines you need to help you – you can always rub these out afterwards.

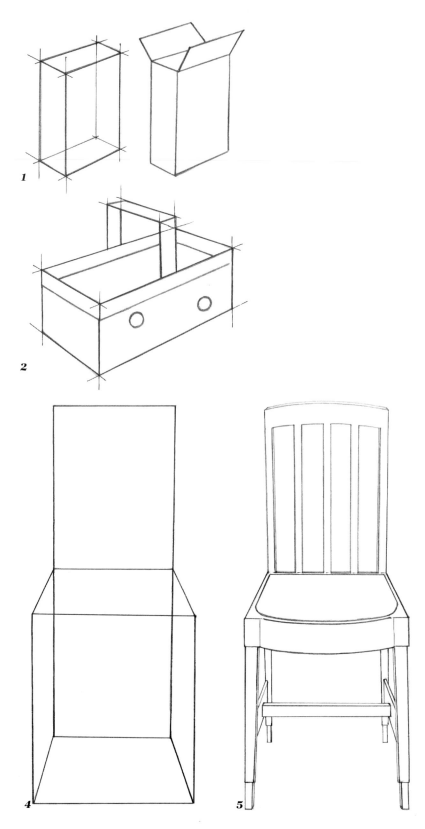

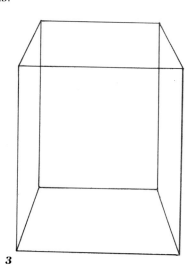

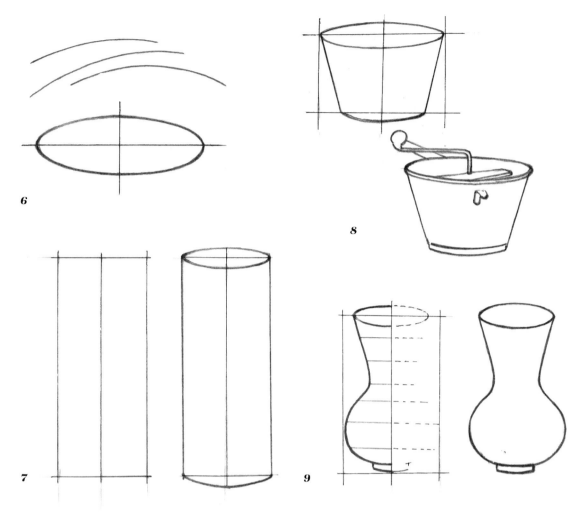

6

8

7

9

Cylinders and symmetrical shapes are a little more complicated! Practise some curves and ellipses first. Always draw a curve from the inside, and if possible with a natural, continuous flowing movement of the hand. Turn the paper round or upside-down so that you can get at curves in this way. You can see from illustration **6** that it is best to use central guide-lines across the length and width of an ellipse or oval shape to help you draw it more accurately. Check that the ends of the ellipse are rounded off and not too pointed – remember that you are looking across a circle, so there are no corners!

Construct a cylindrical shape in the way shown in illustration **7**. Draw some guide-lines to make a rectangle based on the width and height of the cylinder, and then add the curves to the top and bottom. Variations of the cylinder shape can be developed from this, as shown in illustration **8**.

Other symmetrical shapes are also balanced either side of a centre line, so use the same sort of approach for them as when drawing a cylinder. For a shape like the vase

shown in illustration **9**, start by drawing a rectangle based on the widest and highest parts of the object and put in a central guide-line. Study the outline shape of the object, noticing where it changes direction and relating these points in proportion to the whole. Concentrate on one side and draw a few guide-lines across at significant points to help you construct an accurate outline. If you are right-handed, draw in the right-hand half of the object, and *vice versa* if you are left-handed. Have a look at the drawing on the left in illustration **9**.

Now carry these guide-lines across to the other side of the rectangle, making each of the new lines the same length from the centre as its opposite half in the part already drawn. Draw in the other half of the symmetrical shape so that the outline passes through the ends of the series of guide-lines you have just made. Complete the shape by adding the ellipses at the top and bottom, and any other details such as handles. You should then have the perfect symmetrical shape, as in the right-hand drawing in illustration **9**!

Buildings

Modern buildings may have good, clear lines and obvious form and symmetry. This makes them easier to draw, particularly if the main structure is basically a large box, although it certainly doesn't make them interesting subjects! Older buildings will be far more challenging, and make more exciting material for drawing, but may have the disadvantage of an undulating ridge-line or a lop-sided dormer! All drawings, of course, should be interesting, and experience helps us to select topics which will make good drawings, or to interpret mediocre ones to the greatest advantage. There are plenty of interesting buildings about and plenty of fascinating details, giving scope for a wide range of approaches and techniques. But as always, begin with something easy, that will help you grasp the essentials of making a well-observed and accurate study for the particular subject area. So, begin with a modern building!

Obviously perspective is an important consideration when drawing a building. Buildings are large and often viewed from an angle, and therefore present the dual problems of a dramatic reduction in scale and getting the right feeling of depth. It is worth practising some simple building shapes like the one illustrated on p. 43, before progressing to the sort of colour studies shown on these pages. Remind yourself too of the theory and use of perspective, also on p. 43.

Start with some freehand pencil sketches of a simple building viewed from one corner. Put in all the lines of perspective (to the edges of the paper) and any other guide-lines that you find helpful. Draw in the *complete* building, so that, in effect, you show the other side and corners, even though you can't actually see them. Think of the building as transparent! This will help you check the perspective and give you a better understanding of the basic structure. You will have noticed from the previous pages in this section that the motto

1

2

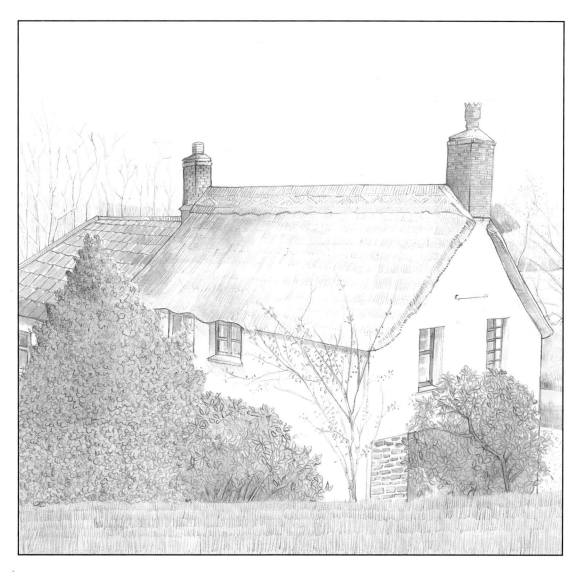

3

for any accurate observation drawing is 'start with the simple shapes'! So you may need to think of your building as a collection of boxes joined together under a triangular-sectioned roof. Put in doorways and windows, and notice how the shape of these is also determined by the perspective of each side.

With older buildings of irregular shape start with straight guide-lines and perspective lines, and modify these to fit the character of the building.

Try a sequence of drawings based on the same building but using different viewpoints, as in the illustrations on these pages. Notice the influence of perspective in these drawings, particularly with the acute angle shown in illustration **2**. These drawings were made in pencil line with watercolour wash. There are many techniques to choose from,

although possibly pencil and pen techniques are best, because they can give a combination of precise lines with the various other effects needed for the different textures of stone, brick, thatch, etc.

A really detailed drawing of a complicated building, involving a variety of shapes and textures with some of the surrounding setting, will take many hours of work. You may not be able to do all of this work on the spot, so use a sketchbook to take down notes and 'visuals' of different details and perhaps work from other site drawings and photographs. Take notice of my advice and comments on using photographs, (pp. 62 and 63). Photographs can badly distort the perspective view of something – so be wary! *See* also pp. 19, 24, 27, 40, 41 and 66.

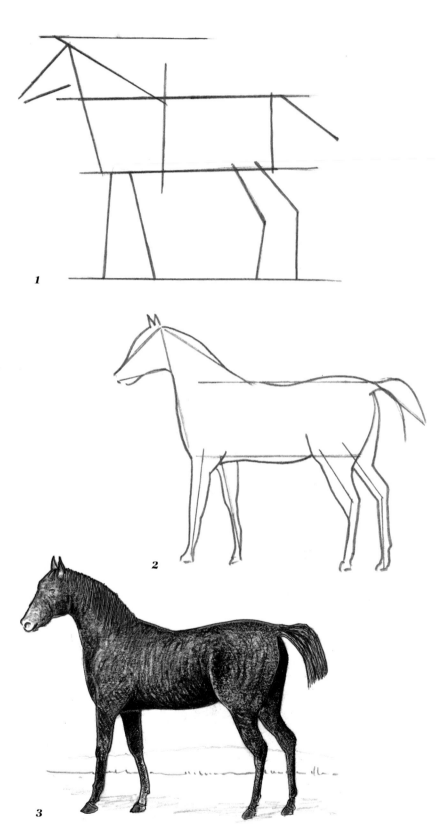

1

2

3

Animals

Start with the simple shapes! These aren't always easy to find in an animal, but, as with the human figure, there is an underlying skeleton. So think in terms of the skeleton and work the drawing up from that. An added difficulty is of course that animals move! Very often you will be drawing from life – sketches made this way are certainly best. You can get just the pose and information you want by going out and making some drawings from the real thing. As the animal moves around, you won't be able to produce fine, finished studies, but you will be able to capture the essence of a pose and the characteristics of the beast! If needs be, work on several sketches at once, returning to each as the animal re-adopts the correct pose. Think of the wonderful sketchbook studies of sheep by Henry Moore, and you will certainly be inspired to persist. You can use sketchbook work done in this way as the basis for more developed drawings done in the comfort of your studio.

Study the main shapes and proportions of your animal and make a sketch similar to illustration **1**. Reduce what you see to a few basic shapes. Look particularly at the size of the head in relation to the body, and the length of the legs. You can work on the basis of a matchstick type animal, as I have done, using straight lines and fairly geometrical type shapes, or you can think of these basic shapes as a collection of sausages! Now work round your guide lines (or sausages) and evolve a more realistic outline, as in illustration **2**. Have a long, hard look at the animal before going any further, and decide what are its main characteristics and details. What makes it that particular animal? You can then go on to add tone or colour and develop those characteristics and details. As with the human figure, don't overdo the shading. Get a good contrast between light and dark areas, and use tone where it helps to suggest the form of the body.

A drawing suffers if it is laboured through various stages of development. For the beginner this is a necessity, as it is well worth learning a few 'tricks' to help master different forms and, in consequence, to develop ability and confidence. As you gain experience you

may wish to dispense with some of the preliminaries, for, sharp of eye and deft of hand, you will be able to make a more immediate response to subject matter. Certainly a drawing gains in vigour and impact if it flows spontaneously from the artist's hand. Look at the two pencil drawings by Thorburn in illustrations **4** and **5**. Here the artist has done just enough with the drawings to capture the character of the animals; he has kept the drawings lively and interesting. So don't despair if your first attempts at drawing animals look like a taxidermist's rejects! Persevere – you probably won't become Archibald Thorburn, but you might get fairly close!

4 Mountain Hare, *by Archibald Thorburn. Pencil. Blackburn Museum and Art Gallery*

5 Otter with Salmon, *by Archibald Thorburn. Pencil. Blackburn Museum and Art Gallery*

PLANNING YOUR DRAWING

Drawings can be made very quickly, perhaps in a matter of a few minutes. You won't need to spend long on many of the drawings you make and, with much of the work you need to do, for example in your sketchbook, time is very limited anyway. Exercises, practice pieces, composition sketches, preliminary ideas, technical experiments, and so on, are not generally demanding of time and won't need much in the way of formal planning. But masterpieces take longer!

As you become more involved in drawing, and experienced in different techniques and subject matter, you will discover subjects and ideas that really interest and inspire you and which you wish to develop into really good drawings. Whatever subject you find most appealing, whether portrait, still-life, landscape, imaginative or abstract, you will find a major piece of work is well worth some careful planning. Whilst a thumbnail sketch might take only two minutes, a large, detailed drawing could take several days to complete. Studio drawings of this sort do need some organization if they are going to succeed fully. Maybe too much preparation can dampen the spirit of the drawing and stifle some of the emotional involvement, but, on the other hand, tackling an idea which has been only half thought out will lead to frustration and disappointment.

To begin with, stick to making drawings of familiar items, events and scenes, so that what you know about them already strengthens the drawing. This doesn't mean that the subject matter has to be dull and dreary. In every drawing there must be a challenge, otherwise the finished drawing will be dull and dreary too! Each drawing must be a new experience, so look at the most commonplace object as though you had never seen it before.

With experience you will be able to perceive the general aims of the drawing and visualize the eventual result, but until you reach that stage, rely on some very careful planning. Think of practical things as well as those which actually concern the content of the drawing. What will you need in the way of equipment? What sort of paper are you going to use? How large is the drawing to be? Work out the composition carefully and do any necessary research before you begin. Experiment with techniques so that you can

be sure a certain method will work. The pages in this section will help you with some of these practical issues, whilst those in Section 5 should give you plenty of ideas and inspiration.

Research

More often than not you won't have to think of something to draw. With so many challenging subjects about, it will be a question of which one you decide to tackle first! But in any drawing you need to have a

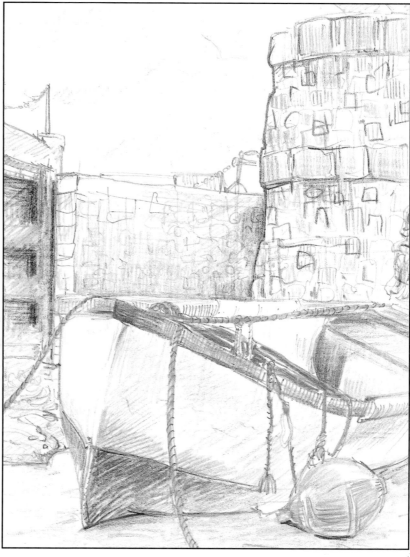

1

clear aim. This will give you a sense of direction and will help you enjoy and complete the drawing successfully. So start by defining your aim. This could be conventional, like making a detailed study of a derelict barn, or more personal, like expressing the feel of a windy day, or analytical, like making a semi-abstract landscape. The aim may be concerned with a certain technique or medium. It will set you a problem which you will need to plan how to solve. Then you can make a drawing to suit the aim and method you have planned.

After some preliminary rough sketches, you will probably want some more accurate information about your subject matter before you can start on the detailed drawing. The best sort of research is looking and drawing – taking your sketchbook and making some studies from the actual thing. In this way you can note down exactly the detail, viewpoint or particular information you want. Also, this helps keep the work very much your own, rather than based on copies from other sources. You will find some ideas and advice for using your sketchbook on the next double page. Illustrations **1** to **3** show the sort of research drawings that are helpful. As well as a main composition, like illustration **3**, think of the sorts of details you need, as in illustrations **1** and **2**.

Agreed, it isn't always possible to go out and make research drawings in this way, so you may have to resort to photographs, books and the works of other artists. Even if you have some good sketchbook studies, a good photograph can give some extra detail to refer to. The main point is not to copy from these sources, but to use them purely as reference and to build up your own ideas from them. Working from photographs and drawing inspiration from other artists are discussed more fully on pp. 62 and 74.

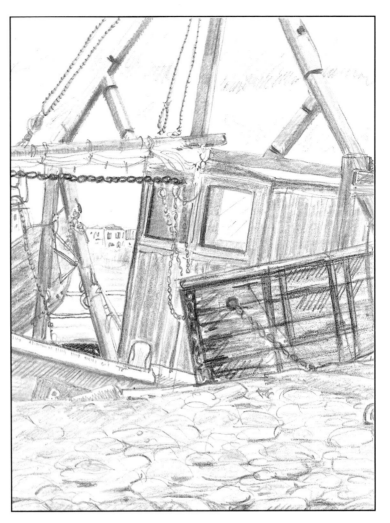

2

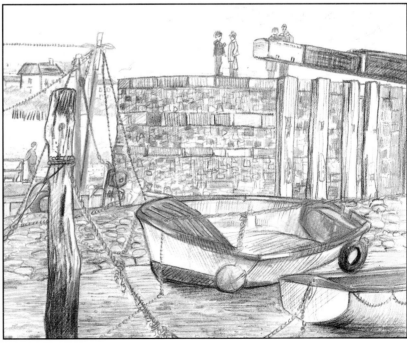

3

Using a sketchbook

You will find that there is a wide range of sizes and types of sketchbook available and that these are supplied under a variety of names: sketch blocks, drawing pads, layout pads, drawing books, and so on. Two kinds of sketchbook are practically essential: an A4 cartridge sketchbook for general use, and a small pocket book for jotting down visual notes and ideas as you come across them. In addition to these, you may find you need a certain type of sketchpad to suit the particular ideas and media you normally use. For example, if much of your work is in pastels you could select an A3 sketchpad with sheets of pastel paper, rather than cartridge. If you work in a linear way, mostly in ink, a layout pad containing sheets of thin, smooth paper might be best, and so on. Remember that the type of paper influences how the medium responds, so think about the size and type of sketchbook that will suit you best. Instead, you may prefer to make your own

sketchbook, perhaps using an A4 ring binder and loose sheets. With this, you can use sheets of different types of paper and therefore a whole range of techniques.

Feel free to use your sketchbook in any way you like. Think of it as a place for uninhibited ideas and experiments – you needn't show it to anyone else! Use it as much as possible; draw in it every day. It is one of the best ways of improving your drawing. Of course there will be lots of things in it which simply do not work and which are bad drawings. But one of its main uses is for thrashing out ideas and solving problems so that you don't make mistakes elsewhere.

So your sketchbook will fill up rapidly! Remember it's not the place for a collection of neat and highly finished drawings. Use it for 'thinking' in a visual way in different media, as well as for planning and research, location drawings, studies and details, and experiments, If you wish, add written notes to your sketches to remind you of other information and ideas which will expand on

1 Study of three cows, *by John Constable. Pencil. Royal Albert Memorial Museum, Exeter*

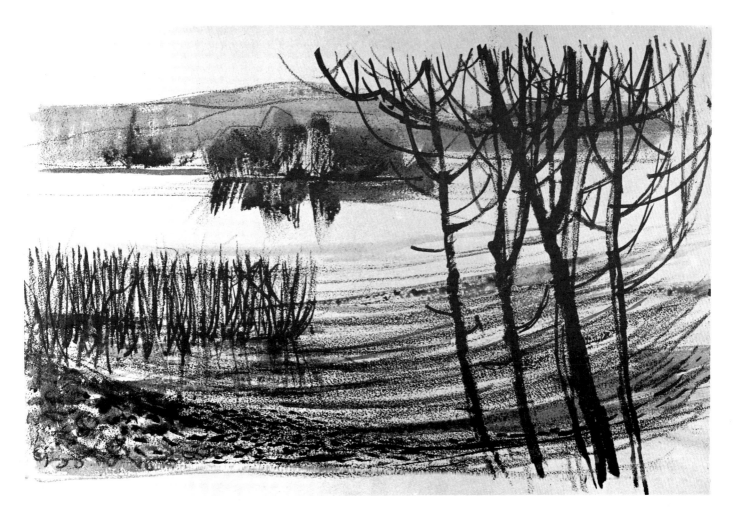

what is shown in the drawing.

Don't use just pencil in your sketchbook. It will look a lot more interesting if you try out a variety of media and techniques. Charcoal, chalks and pastels are good media for making quick drawings on the spot. Pastel is especially good for making a quick colour sketch. For other drawings you could use pencil line and colour wash, charcoal pencil or soft pencil, coloured pencils, and technical pens, ball-point pens or harder pencil for more detailed studies. The sort of contrasting drawings that can be made in a sketchbook are shown in illustrations **1** and **2**.

The essence of good sketchbook work is to do just enough to be informative. See how this is done in the wonderful little group of cows by John Constable. Notice the soft touch of the pencil work and the controlled use of tone. Look at how he has captured something of the character of the animals. It is the sort of sketch that could be very useful in working out a much larger composition, perhaps for a painting. This is equally true of the landscape by G. S. Edwards in illustration **2**. This time the medium is ink and again there are plenty of points and 'reminders' in the sketch that would help if the idea were developed in more detail.

2 Derwentwater, *by Garth Edwards. Ink and ink wash.*
Blackburn Museum and Art Gallery

Working from photographs

This is a prickly topic, for there will be those who totally shun the idea of working from a photograph, whilst others are prepared even to project a slide on to a sheet of paper and draw round the outlines! Let me describe various ways of using photographs, the advantages and disadvantages, and you can make up your own mind as to their value.

You can use any photograph as a source of reference. So, whether it is yours or someone else's, whether it is in a book or magazine, or from another source, you can look at it to help you draw a particular object or scene. You may be tempted to copy directly from the photograph. My personal view is that photographs can be helpful and that there is some justification in using them as additional reference, but they can be inhibiting if you rely on them as the sole source of information and inspiration. Remember that a drawing must have a bit of you in it! You are creating the drawing and there should be something personal in it which you wish to communicate to others. If you rely on a second-hand source of inspiration, like someone else's photograph, you are not likely to get much of that personal touch into the work.

Of course, there are times when your only kind of reference is a photograph. If you were making an imaginative drawing for example, in which there are nomads trekking by camel across the Sahara Desert, then you might have to look at a photograph to help you with the detail of your drawing. Although first-hand sketchbook work is the ideal way of finding out information, not everyone can jet off to the Sahara to make a few location sketches! But even in this situation you should aim to modify things to fit your original idea, rather than make direct copies.

On the other hand, photography is an ideal way of capturing the fleeting moments of action or places and events that cannot be revisited. But again, try to support those holiday snaps with your own observations, whether written or sketched.

There are artists who feel justified in working directly from their *own* photographs or slides. Having taken the photograph themselves they have obviously been to the

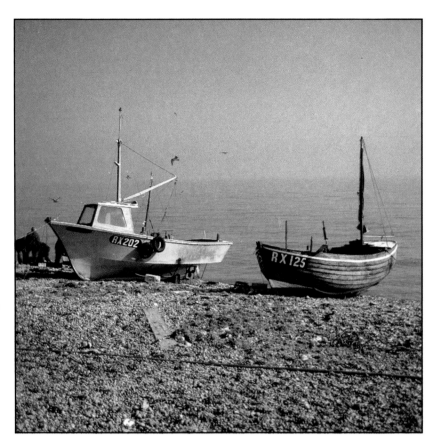

1 (Above) *2 (Below)*

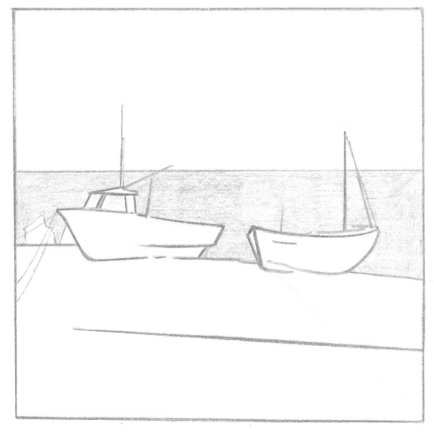

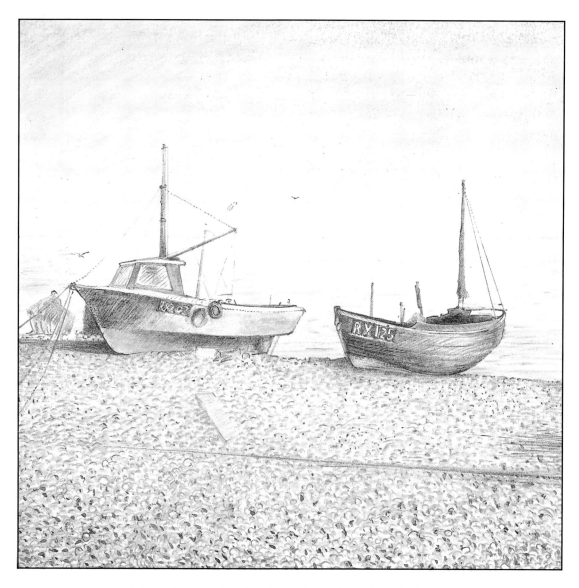

3

place and witnessed the subject at first hand and may well have made some notes and sketches as well. They would argue that for a landscape view, for example, there is little point in persevering in the cold to make a pencil drawing of the best composition when a camera can give you a selection to choose from.

The composition of a photograph can be enlarged and reproduced almost exactly by the squaring-up method described on p. 66. A colour slide can be projected on to a sheet of paper so that you can draw round the outlines. I used this method for the illustrations on these pages. Illustration **1** shows the original colour slide, **2** the outline drawing, and **3** the completed work. Whilst working on the final illustration I was able to refer to the actual scene projected on to a screen beside my table! However, notice that

the end result isn't photographic, but through the use of different media and techniques available to the artist it creates something more personal.

The use of mechanical aids in drawing is always something for debate from opposing philosophies. In relatively few years' time I wonder how much artists will rely on computers? Will you be able to use a computer with individuality and feeling to express your ideas? Time will tell.

Composition

Composition is the way you decide to arrange the different shapes that make up your drawing. It is an important factor in the success of any drawing. Whilst an unusual and interesting composition will add to the impact, a poorly planned design will only detract from the work, no matter how expert you are with technique. Even if you are drawing just a simple object you need to consider the size and position of it on the paper and how it relates to the background shape. Composition is not just about the positive elements of your drawing (the main shapes of the things you are drawing), but equally the negative spaces (the gaps or background areas).

Good composition can depend just as much on what you decide to leave out as on the way you arrange what you decide to put in. Start by having a look at some paintings and drawings by well-known artists. Notice how they have arranged the main shapes of the picture to give some interest and impact to their ideas.

Many paintings used to be based on a contrived design using a proportion known as *The Golden Section* or *Golden Mean*. This is a mathematical proportion accepted by the great artists and scholars of the Renaissance as having special artistic significance and aesthetic value. Harmonious and visually satisfying proportions of the parts of many pictures worked out by pure intuition or formal calculation appear to correspond with it. As well as having a relevance to art, mathematics and man-made structures, it was also found that this proportion appears in nature, as for example in the growth patterns on shells.

The exact proportion is 0.618 to 1, or roughly 8 to 13. Therefore, in drawings and paintings the use of the *Golden Section* would provide a division so that at roughly two-fifths of the way across the picture area would be placed a tree, a column, or some other significant feature within the total design. The small tree in illustration **1**, for example, divides the composition in this way. This creates an unbalanced composition with the proportion of the smaller area to the larger the same as that of the larger area to the

whole. Illustration **1** shows this kind of exact division, whilst illustration **2** shows how to reach such a division quickly and approximately by dividing the picture area into thirds.

1　　　　　*2*

Another conventional composition is the head and shoulders portrait, illustrated by the triangular *Madonna and Child*. In the great painting of the *Last Supper* by Leonardo da Vinci, the structure of the composition is such that it leads you into the central figure of Christ. In contrast, painters like Van Gogh and Matisse used a much less obviously structured, and seemingly more spontaneous and intuitive kind of composition.

You may like to consider symmetry and asymmetry, balance and contrast or the interplay of light and dark areas, etc. An abstract drawing might need a very balanced design but in general look for some means of achieving a contrast in the way you use shapes and tones.

Now look at the illustrations to check some other points on composition. Compare the two still-life designs in illustrations **3** and **4**. In the first example my arrangement of the objects is not very exciting, is it? The jug is almost exactly in the middle of the design, and there is little contrast in height between the three largest objects. Similarly the bases of three out of four objects are level. This makes for a compact group and not a very lively composition.

So, I've tried to do something about this in the second illustration. I've swapped the bottle for a taller one to give some contrast in height and I've isolated the glass on the left to give a gap between it and the other objects. There is now a more interesting arrangement of base shapes on the table area, with an extra object brought in to liven up the foreground. Consequently I have altered the composition

from a lengthways design (*landscape*) to an upright design (*portrait*). Do you agree that it has more impact?

Be prepared to try out several different composition ideas before you start a major piece of work. These need only be line drawings or quick sketches, but they will give you some alternatives to look at and compare. You will then be in a better position to judge which composition is going to work best and help give you the effect you want.

much more natural with flowing lines and angles and has a better contrast between spaces and forms.

Composition is a bit like perspective – you can easily get weighed down by the theory and this may destroy the momentum of work. Bear in mind the points I have raised, but rely also on your own intuition and feeling as to what looks and feels right.

See what you think of the composition in the drawings on pp. 2, 7, 8, 11, 19, 33, 49, 59, 79, 85 and 87.

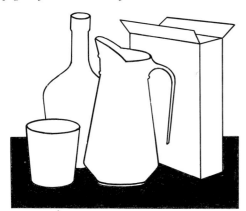

3

5

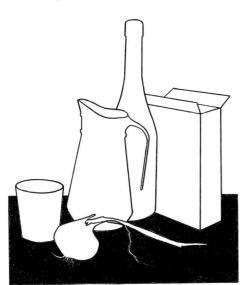

4

6

Three compositions of the same subject are shown in illustrations **5** to **7**. Each has some merit but I would choose illustration **7** as the best. This is because I consider **5** to be too symmetrical and **6** to have too many rigid vertical and horizontal lines. The composition in **7** fits the subject matter much better; it is

7

Enlarging and transferring ideas

Quite often the main drawing is worked up from a much smaller composition sketch. Your design on a sheet of A5 paper may have to be enlarged up to A2 size. Although it is not always necessary to be absolutely accurate in the way you enlarge your sketch, you will want to keep the basic proportions (the size of one thing in relation to another) the same. So it is useful to have a method to help you do this.

First check that your larger sheet of paper is in proportion to the smaller one. Look at illustration **1**. Place the sketch on top of the larger sheet of paper in the bottom left-hand corner so that the bottom of the sketch and its left-hand side correspond to those of the big sheet. Now place a long straightedge diagonally across the sketch from bottom left to top right so that it also extends across the larger sheet. Any larger rectangle constructed with its top right-hand corner on this diagonal will be in proportion to the original.

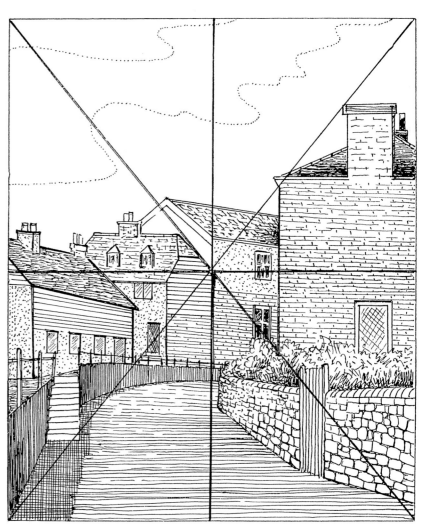

2

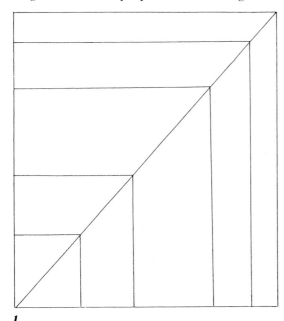

1

For speedy enlarging make use of just a few faint guide-lines. The simplest way is just to divide the paper half way across both vertically and horizontally, and with diagonals. Do the same to your small sketch, as in illustration **2**, but cover it first with

tracing paper if you don't want to spoil it. Now you have divided your composition into various areas that you can simply draw out on a larger scale to fit the corresponding areas on the big sheet. The guide-lines will give you some indication of the position of the main shapes. In my drawing, for example, the corner of the roof and chimney of the building on the right fit almost exactly on the diagonal, and I can assess other measurements from these guide-lines.

A conventional way of transferring a preliminary drawing to a canvas, or enlarging a sketched image onto a bigger sheet, is to use the squaring-up method shown in illustrations **3** and **4**. This method will give you an accurate enlargement. Take the

original sketch and divide it up with a grid of squares, as in **3**. Draw the squares directly over the drawing if you wish, or cover it with tracing paper first. Measure along each side to work out how many squares to use. Don't use too many or the process gets far too involved and time consuming! Stick to about four or five along each edge for a small, simple design. Of course, your paper won't always exactly divide into squares – there may be a bit over. Don't worry about this as the same will happen on the bigger sheet which you have remembered to cut in proportion!

Draw a similar grid on the larger sheet of paper with faint lines which will be easy to rub out afterwards. Use the same number of squares long each side as you did on the small sheet – each square will of course be bigger.

Referring to your original sketch, take each square in turn and re-draw the part of the drawing in that square on a bigger scale, to fit the corresponding square on the large sheet. With the outlines you want you can now develop the larger drawing, like illustration **4**.

Enlargements can also be made by using an episcope, or similar machine, to project and magnify the image, or by using an enlarger or pantograph. See also **Working from Photographs** on p. 62.

3

4

Preparing the paper

The type of paper and the way it is prepared for use can have a dramatic influence on the outcome of the drawing. I reiterate the need to check the suitability of the paper for the media and effects you have in mind. If you have any doubts then test out the medium on some offcuts or scraps of paper of different types to see which gives you the best response. But in addition to choosing the paper, you may need to prepare it in some way before beginning the drawing.

Not everyone likes to work in the same way. You may prefer to have the paper loose so that you can twist it round and get at the drawing from different angles more easily, or you might find it better to use drawing pins or a board clip to secure it in place on a drawing board. But, as in illustration **1**, always leave yourself a margin round the work. So choose a sheet of paper a bit bigger than the drawing area – this will give you scope for mounting and presenting your masterpiece later.

If you intend using wash techniques, or other methods, like spraying, which are likely to wet the paper, then it is best to 'stretch' the paper first. The only exceptions will be if you are working on thick watercolour paper and card. Stretching will stop the paper drying in a wrinkled or distorted state after being wetted.

For a drawing that will include just a small area of tint or wash you need only dry-stretch the paper. This means fixing the paper to the drawing board with masking tape or gummed tape around all the edges. Otherwise, give the paper the full treatment!

The process is shown in illustrations **2** to **5**. First dip the sheet of paper in clean water, either in a tray or a clean sink, or apply water with a large sponge. Make sure both sides of the paper are wetted completely. Place the wet sheet of paper flat on a drawing board. Work quickly before the edges begin to wrinkle. Apply wetted strips of gummed tape around all the edges. The strips should be long enough so as to overlap and be folded under at the corners, see illustration **4**. Use two strips of tape down each edge for a very large sheet of paper. Use a wet sponge to persuade the strips to stick to the paper. Let them follow any wrinkles in the paper – don't

crease the paper. Ensure that the corners are neat and secure, as in illustration **5**. Leave the paper flat to dry out thoroughly. You'll be surprised at how this seemingly useless soggy piece of paper will transform into a completely flat sheet ready for you to begin your drawing.

Some drawings may need treating with an initial background colour or tone, which you can then work over in a more detailed way. This can be applied as a thin wash (or washes) of colour (*see* p. 32), as spray (*see* p. 30), or by using a dry tinting technique, as in illustration **6**. Use pastel or chalk for this, or even dry pigment such as powder colour. Shade the paper over lightly, using the pastel stick on its side. Now use your hand, a piece of cotton wool, or a cloth, to rub the pigment into the surface of the paper and create a weak, even tint of colour. You can use charcoal in a similar way for creating a lightly toned background for further detailed drawing in pencil and charcoal pencil.

1

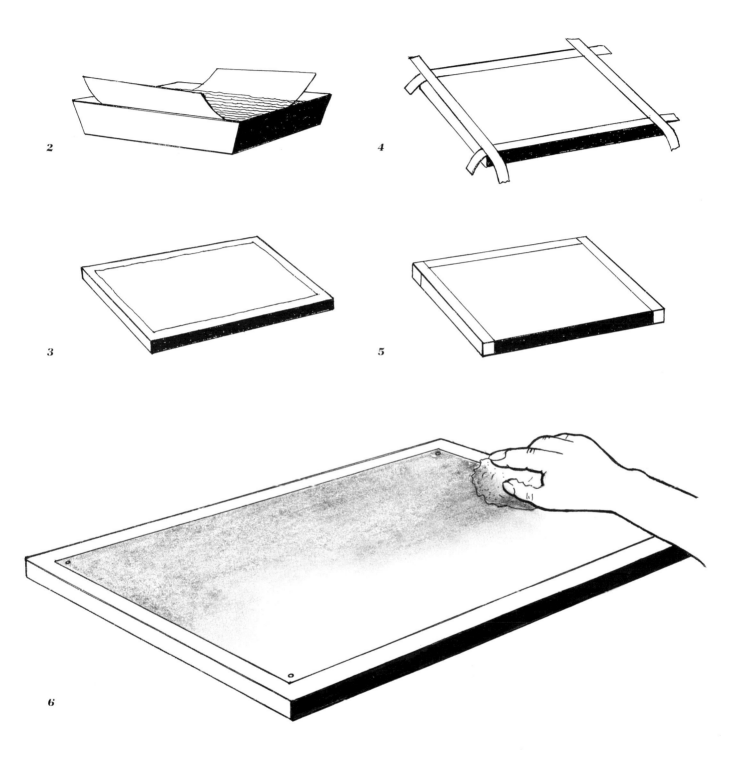

2

4

3

5

6

Working in stages

After all the planning and research, and the deliberations over the best composition, you will actually be ready to begin your main drawing. As always, it helps to be organized, and to think in terms of working through various stages.

First check what you need in the way of equipment and make sure everything is at hand and in good working order. There is nothing worse than reaching a crucial stage of the drawing only to find that the particular pen you wanted to use has a broken nib or that you have just sat on the last stick of charcoal! If required, prepare the paper in one of the ways described on pp. 68 and 69, and then sketch in the general design or enlarge it up from a previous drawing, as shown on p. 67.

Don't concentrate too much on one particular area. Try to keep in mind the whole drawing and how each part fits in with the total idea. So don't completely finish one

1

small area and then move on to the next – work the drawing up gradually, step-by-step.

2

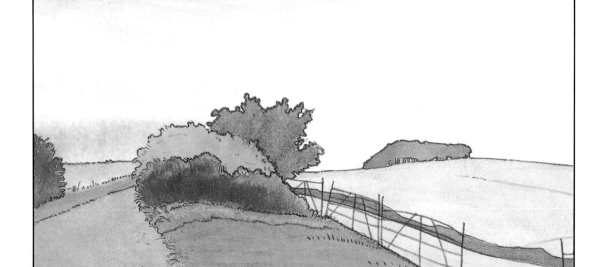

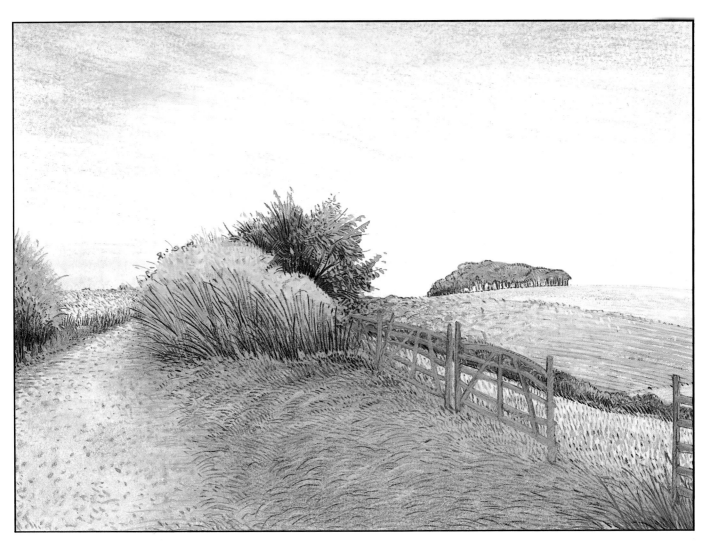

3

After sketching in the composition, as in illustration **1**, block in any basic tones or colours you need for general background areas. This may not always be necessary, of course, but will depend on the subject matter and the sort of treatment you have in mind. Certainly any general washes, spraying or dry tinting should be done at this stage. In illustration **2** I have used some basic washes of colour.

Work from the background to the foreground and, as much as possible, from the top of the drawing towards the bottom. This will help you prevent any undesired smudging of the fine work you have just finished. Usually, the background will be weaker in tone than the rest of the drawing, and will involve less in the way of subject matter and detail. This contrast will help create some space and depth in the drawing. Have another look at pp. 44 and 45 if you are unsure about this.

Now work over the drawing with whatever

detail is necessary. In my drawing in illustration **3** I have worked more colour and feeling into the sky with pastels, and have used a combination of coloured pencils, pastels and brush drawing to achieve the various textures and effects of the foreground. So choose other media to help you achieve the sort of definition and detail you need.

Finally, when you think you have finished the drawing, check over what you have done and see if there are any parts you could improve. Sometimes it is best not to do this straight away but to leave the drawing for a few days. You can then return to it with a fresh, critical eye and see if there are any details which need attention, or even redrawing in some way. But don't be too critical! It won't be possible to make major changes. In any case, you may be pleasantly surprised by your efforts!

Completed drawings may need spraying with fixative and you can then decide how to mount and display them (*see* pp. 88 to 91).

IDEAS *and* PROJECTS

Every artist is a student. I suspect that even a great master like Leonardo da Vinci would say that he still had things to learn. Although we may be well satisfied with some of our work, we never produce anything that is perfect – there is always scope for improvement.

To begin with, we have to go through a period of initiation. There is much to find out about materials and techniques and about the basic craft of drawing. With some experience we begin to find a direction in our work, a type of drawing or perhaps a specific subject matter that intrigues us most. We can build on this interest and develop a style of our own, a way of seeing, interpreting and drawing that is marked with our individual personality.

My aim in this section is to show some of the main areas of subject matter, to give some general advice and information for each, and to suggest further ideas and projects to explore. The choice of subject matter is, of course, a personal thing. Whereas one artist will be moved by the drama of a landscape, another will be fascinated by the interplay of light and dark in a formal still-life group. Obviously the drawing will be a greater success if you choose ideas and themes that really interest you. But avoid the temptation of repetition. You may know that you can get a good result with a particular technique or idea and it is therefore tempting to have another go at it. However, if the drawing demands something more of you, it is not only more likely to be a greater success, but will contribute towards your general artistic development.

Cézanne, Monet, Degas, Picasso and many other great artists might appear to prove me wrong on that point. Cézanne, for example, did numerous drawings, watercolours and oil paintings of the famous *Montagne Saint-Victoire*. But Cézanne didn't repeat the subject just because he knew he could draw it well. He found the theme remained inspiring, that there was still much more to find out about it and many exciting drawings to do.

So, you can take a tip from Cézanne and explore a single theme, or you can cover a large variety of subjects – there are plenty to choose from! Remember, each drawing is a new start and needs a fresh vision.

Types of drawing

In a drawing, you are communicating with other people. You set out with a reason for making the drawing and usually this will affect the type of drawing you produce. You might want your drawing to be informative,

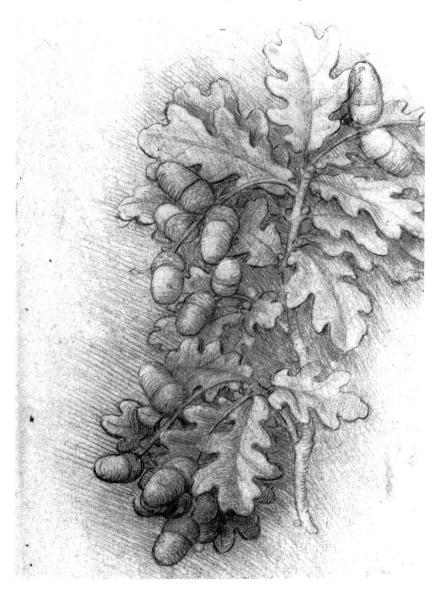

1 Oak leaves and Acorns, *by Leonardo da Vinci. Chalk.*
Windsor Castle, Royal Library, Her Majesty the Queen

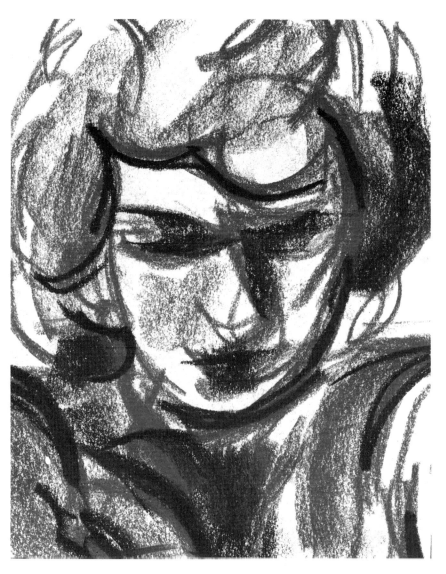

2

possible and therefore may need to make a whole series of drawings to show different viewpoints, aspects and qualities of the subject – texture, detail, colour and so on. Analysis coupled with simplification can lead to various forms of abstract art. For example, you might draw a tree in a totally realistic way to begin with, and then gradually reduce the shapes you see to simpler and more geometrical ones.

Other drawings can be subjective. You can concentrate on and emphasize those qualities in the subject that interest you most, or alternatively, you might be intrigued by the play of light or different colouring effects. What you feel about the subject will determine how you interpret it. Illustration **2** is an example of this. In other drawings you might decide to let the technique dominate, as in illustration **3**, with a stylistic result.

There is a good range of examples of different types of drawing shown in this book. Have a look at some of them again and don't be afraid to experiment with a wide variety.

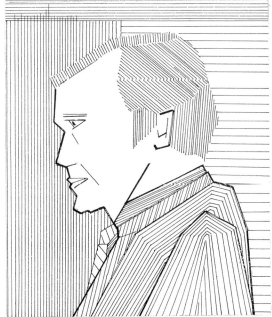

3

representational, analytical, expressionist, subjective or decorative.

To begin with many of the drawings you make will be based on straightforward observation. You will be looking at something and trying to record it as accurately as possible – trying to make it look like the real thing. This type of drawing is known as representational or naturalistic. You might draw a still-life group like this or perhaps make some detailed studies as research for a larger composition.

Any drawing is informative in a sense. If it does not make some sort of statement then it wasn't worth doing! But some drawings, like the Leonardo study in illustration **1**, are made especially to show as much detail and information about the subject as possible.

Similarly, you can take the process further and be analytical in your approach. You may want to study the subject as thoroughly as

Looking at drawings

Get into the habit of looking at as many drawings as possible. Look at work by your friends as well as that of some of the great masters. Raid the art section of your local library and, better still, see what bookshops have to offer, and start to build up a reference library of your own. You can often find some very interesting books in second-hand bookshops. Ideally, drawings need to be seen 'in the flesh', so when possible visit a good museum or art gallery that has a collection of drawings. Some of the main ones are listed on p. 94.

Enjoy looking at drawings but also view them in an enquiring way. You can learn a lot by looking at other people's drawings. It is interesting to see how another artist has solved a particular problem of perspective, for example, or has used colour or tone, or chosen an unusual viewpoint. You will get some ideas for your own drawings and learn something about the use of different techniques and media. There will be some artists whom you particularly admire and will want to study in more detail. You may find it useful to keep a scrapbook of cuttings, postcards, notes and general ideas for drawings.

Have a careful look at illustrations **1** and **2**. The Gauguin drawing shows a study of a peasant girl made in coloured chalks. On close inspection you will notice that it has been squared up. In fact this drawing was used as the basis for other painted and ceramic work, and the figure appears in the painting *Four Breton Woman Talking*. Many drawings are, of course, done as preliminary work for paintings. As such they have a particular function, but this does not mean that they cannot stand as separate works of art in their own right. My philosophy throughout this book is that drawing is not just something we use to help us achieve a result in some other art technique, it has an individual importance – personally, I think it is the most important form of art. The Gauguin drawing bears this out. The drawing is interesting in many respects, not least because of the confident statement it makes and the delicacy of touch with technique.

From La Grimpette in illustration **2** shows a similar individuality, yet mastery with technique, this time in coloured pencils. Notice the way that there is no attempt to disguise the medium but rather that advantage is taken of its linear and hatching characteristics. Look at the composition and the organization of shapes, and the way Pissarro has suggested great distance.

You often need to look at a drawing more than once to appreciate it fully. Have another look at some of the other drawings by well-known artists in this book.

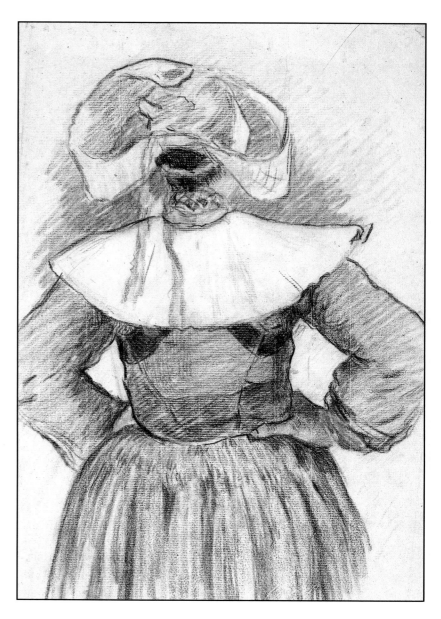

1 Breton Girl, *by Paul Gauguin. Chalks. The Burrell Collection, Glasgow Museum and Art Galleries*

2 From La Grimpette *by Lucien Pissarro. Coloured pencil. Williamson Art Gallery and Museum, Metropolitan Borough of Wirral*

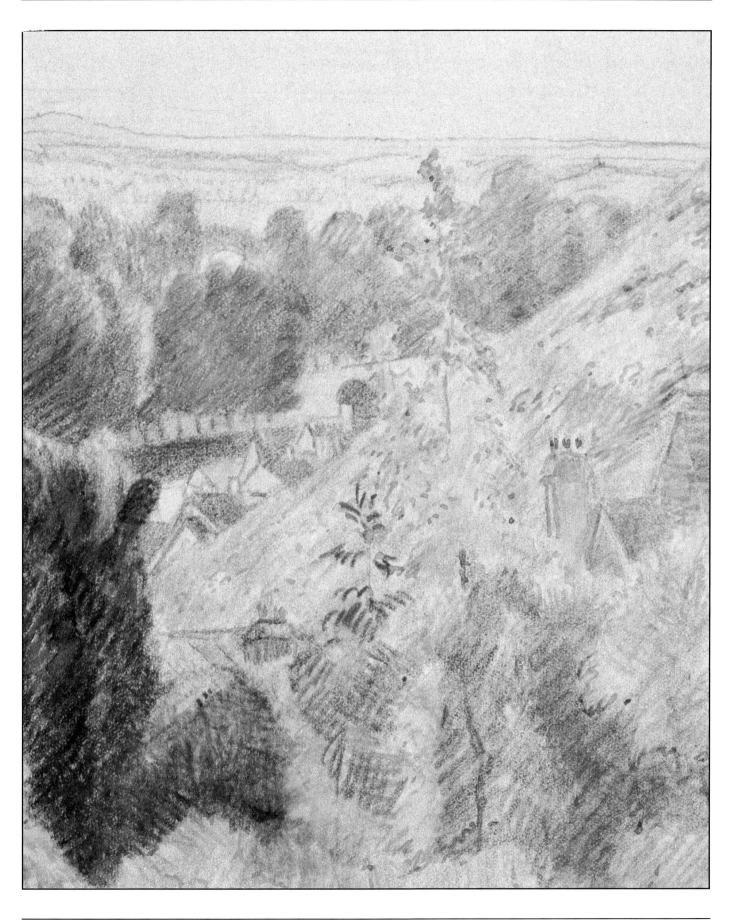

Still-life drawing

The traditional still-life is made up of a group of objects placed on a table, usually with a positive form of lighting so that the shadows emphasize the forms. The great advantage of doing a still-life is that you can control every aspect of the drawing! Although totally contrived, and most drawings are contrived to some degree, this subject area nevertheless gives scope for a wide range of work. For the beginner, careful observation studies from still-life groups are a good way of studying forms, learning about composition, perspective, space and tonal effects, and trying out different techniques.

So, try some still-life drawings. See if you can collect together some interesting objects to choose from. Supplement any you have around the house with some more unusual ones from jumble sales, junk shops, or even rubbish tips! When you are arranging the group, bear in mind my advice on composition on p. 64, but there are no hard and fast rules about content. You could base a group on a certain theme, like gardening or home decorating equipment, or think in terms of colour or texture, or try out different tonal and lighting effects, or go for something far more subjective. Remember that those gaps and spaces are important shapes too. Get other ideas by looking at some still-life pictures by artists like Courbet, Braque, Cézanne, Matisse, Pierre Roy and William Scott.

To begin with, try a simple group placed against a plain wall or screen. Work at about six to eight feet from the group, depending on the size of the objects. Study the objects from a number of viewpoints to see which is the most interesting. If you arrange the group on a drawing board you can twist this round to the angle which seems best. Also, if you cover it with white paper, you can mark the position of the objects on the board by outlining the base shapes. This will ensure objects stay in the right place between drawing sessions! Think of the drawing in these stages: layout and composition; guide-lines and construction of individual shapes; main areas of tone; surface textures and details.

When you have done some traditional still-life drawings, try some variations and

experiments. Your first drawing will probably be in pencil, so try some other media, including working in colour. You can also work in line, or brush and line, for example, and make a series of drawings of the same still-life, but from different viewpoints. What about an unusual viewpoint? For instance, you could place the group on the floor, or draw some items on a shelf well above your eye level. Details are also interesting. Use a card viewfinder to isolate a small area of a still-life, and enlarge this on to your sheet of paper. You can make a viewfinder from a small piece of card, 75 × 100 mm (3 × 4 in). Cut a small rectangle in the middle of the card, about 25 × 40 mm (1 × 1½ in). Hold it up, and look through the hole to find the most interesting bit. The drawing in illustration **1** was made in this way.

You could also try simplifying and abstracting the various shapes within a still-life group. You could work in monotone for example, like the illustration on p. 35, or aim for an effect like the one in **2** (opposite). Here I have taken an outline tracing of the composition and repeated the shapes slightly to the lower right of the original drawing. I have then looked at the whole design and treated each shape with a different pencil technique.

1 **2** (Right)

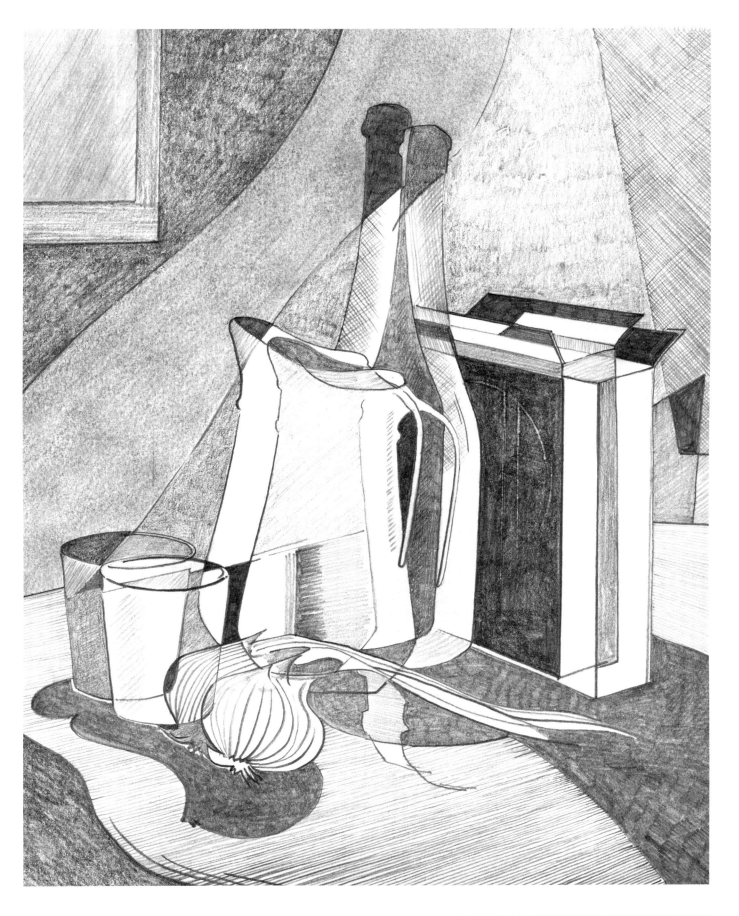

Working from life

Life drawing means drawing the human figure from the direct observation of a live model.

In environmental studies, landscape and imaginative work, a figure, or figures, may be an essential part of the composition. Other figure drawing may take the form of a head and shoulders, or a full length portrait, or a study of a nude model. Look again at pp. 46–49 for some advice on how to draw figures. As always, whether for posed or character studies, nude drawings or quick figure sketches, there are many drawings by well-known artists that will give you some ideas for posing a model or using different techniques.

After you have persuaded someone to pose for you, think about the sort of drawings you would like to make and how you are going to position the model. Whether nude or clothed, the pose of the model needs careful consideration. Usually a compromise is necessary between what can be comfortably maintained by the model and what seems interesting to draw. Try to spare a thought for the poor model as you get more and more involved in your drawing – the model can't keep a statuesque pose for ever! Give the model rests and, if possible, chalk round the position of the body against the backing or floor so that the pose can be reassumed fairly accurately.

Work from both clothed and nude figures if you can. Start with some line drawings based on short poses, and then try some careful studies in different techniques, like the illustrations on this page. The opportunity to draw the nude is not necessarily limited to practising artists. If you don't know anyone well enough to ask them to pose for you then try some classes in life drawing at your local Art College, Adult Education Centre, or Evening Institute.

Two contrasting life studies are shown in illustrations **1** and **2**. The first, a standing model, is clothed and is drawn in oil pastels. The medium is direct – a good one for the inhibited because it is not easy to correct mistakes. Notice the use of a dark crayon to pick out the essential form, the loose use of colour, and the way the white paper has been allowed to show through in places, keeping the drawing lively. The Renoir nude in illustration **2** has been drawn with the more controllable medium of red chalk. Here the form can be modelled with striking contrasts of light and dark. Notice the suitability of medium for each of the two drawings and the two different poses. Such drawings can be developed further by relating the figure to an interesting background.

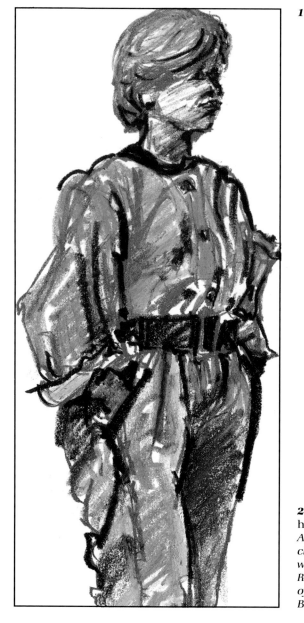

1

2 Nude Woman drying her foot, *by Pierre Auguste Renoir. Red chalk heightened with white.*
Reproduced by courtesy of the Trustees of The British Museum

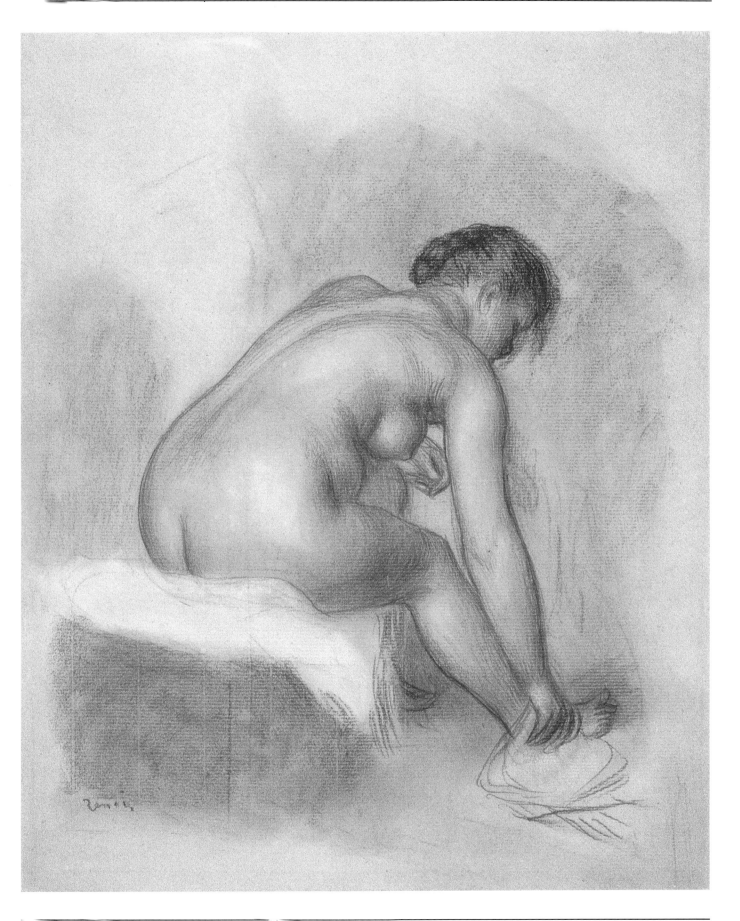

Landscape drawing

Again, there is no substitute for the actual model. You can't invent a good landscape drawing – you need to face the elements and get out and about. Landscape is a very rewarding subject, although for the beginner probably the most difficult. That seemingly pleasant and uplifting view masks some very real problems for the artist. But don't despair – it's just a matter of seeing the wood for the trees!

There is an immense variety of potential subjects in landscape. Think of the broad treatment you might give to a wide, open moorland, or the contrasting detail of a broken willow bough dipping into the river; and what a challenge there is in the brilliant yellow of fields of flowering rape, or the subtle tones of a craggy coastline. Whether open fields, groups of trees, orchard, estuary or coast, there is a wealth of inspiration out there.

Go prepared – physically and mentally. Take your waterproofs and survival kit, but don't forget your sketchbook, drawing materials, paper, drawing board, and so on. Plan the sort of work you would like to do and check what you need in the way of materials and equipment for it. Be prepared for changes in the weather. Make the most of your time out; if sun turns to shower run for cover and switch from your careful study to some quick drawings in your sketchbook of the driving rain or cloud formations! At least you should be able to reproduce these with real feeling!

1

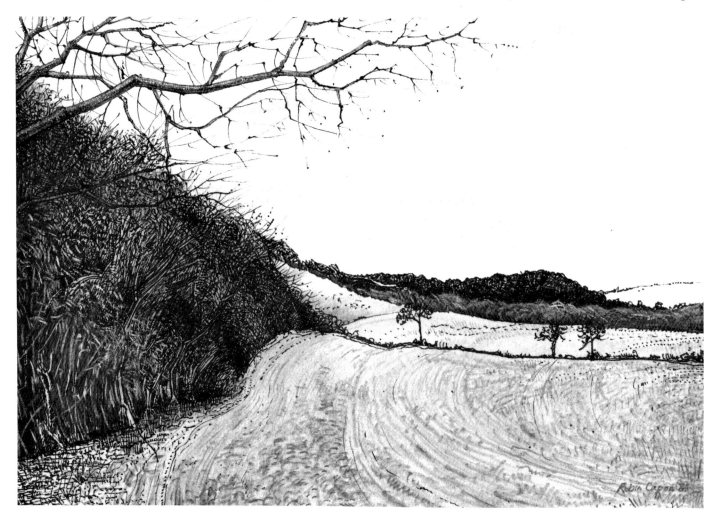

2

But back to the wood and the trees! The panoramic scope of a landscape can cause confusion. Start by sketching in the main shapes. Don't ignore the sky. The space the sky takes up within the design, and the treatment of that area, is an integral part of your picture and forms the background for your landscape. Look at the main shapes of the landscape composition in illustration **1**. You can see that there is a sky area, a roughly triangular wooded area on the left, the foreground shape of the field, and several small shapes between this and the skyline. This framework of general shapes will establish the composition of your work and give it some unity. You can then develop the drawing as described on pp. 70 and 71.

Start with some quick line drawings to help you work out a composition, and decide exactly which bit of a landscape you wish to concentrate on. Another way of selecting a view is to use a card viewfinder, as described on p. 76. Don't try anything too complex to begin with. You could choose a view in which broad areas of landscape are contrasted with

a building, a piece of farm machinery or something of similar detail in the foreground. Alternatively, try a ready-made composition, like looking through a gateway or the view between two trees. Half close your eyes occasionally to help estimate details and concentrate on the main shapes of the idea.

Think about different media and their effects in relation to the sort of landscape you are drawing. Try some colour work using broad areas of wash, pastels and coloured pencils. Look again at the drawings on pp. 70 and 71. Space and depth are obviously important qualities to achieve in most landscape drawings. Remember the advice on pp. 44 and 45 in this respect.

As with any subject, with a bit of experience you will begin to see all sorts of variations. There are many details in landscape that make good drawings, just as you could develop the basic composition in a more arbitrary or abstract way, as in illustration **2**.

Some other ideas are shown in the landscape drawings on pp. 2, 7, 11, 19, 27, 29, 31, 33, 36, 39, 44, 61, and 65.

Ideas from nature

For the beginner this is a good subject area to explore: the shapes are generally small and often durable and they give you the opportunity to do some careful, close analytical work and help develop your drawing skill.

Have a look at a fruit and vegetable stall or a fishmonger's for some ideas. Take advantage of your walks in the countryside and your beachcombing to build up a varied collection of natural forms. From the beach collect shells, driftwood, interestingly shaped or coloured pebbles and perhaps some more unusual remnants of marine life. Look for pieces of bark, feathers, animal bones, stones and flints, as well as grasses, plants and flowers, when you are out on your weekend constitutional. After cleaning, some of these items will keep almost indefinitely and, even if you don't get round to drawing them, will make interesting pieces of natural sculpture to have around the studio.

1

2

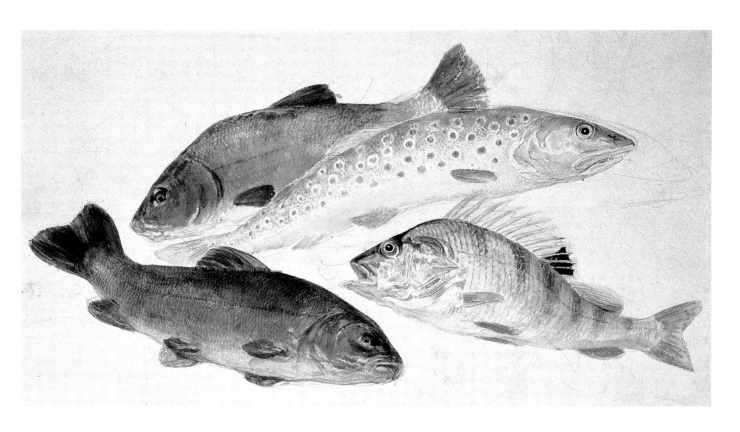

3 Study of four fish, *by J. M. W. Turner. Pencil and watercolour. Tate Gallery, London*

Look at the characteristics of what you have chosen to draw and plan the best approach. Some natural forms are small and uninvolved and thus the drawing can be completed in a single session. With others, like the shell in illustrations **1** and **2**, you can work on the drawing over a period of time, perhaps making a variety of studies. Whilst some objects are permanent and won't deteriorate, others will wilt and fade and demand immediate attention and speedy drawing. But although a shell may last forever, don't be tempted to prolong the study, as with any drawing. A drawing done over a lengthy period of time obviously loses its vigour, and you will possibly lose your enthusiasm for completing it.

Think of the lighting and positioning of individual specimens before you draw them. Arrange them in a good light and place them on a sheet of white paper so that you can see the form and details quite clearly. You don't have to stick to a single item, like the shell, although you could do a whole series of drawings of this on one sheet of paper to show the subject from all viewpoints. Alternatively, you can make a drawing of a collection of shapes, either of the same type, like the fish in illustration **3**, or by making an arrangement of a variety of natural forms, a bit like a still-life.

Colour is often an essential quality in these drawings. Sometimes the colouring is very subtle, but it is nonetheless important. Look at my drawings of the shell in illustrations **1** and **2**. I have done these in coloured pencil and water-soluble pencil over a very thin light wash. The initial wash has helped to enrich the colouring and has given a general background to work against. I have used water-soluble pencils for some areas where I have wanted to blend lines or achieve a smoother area of colour. These pencils are used like normal coloured pencils, except that if wetted with a clean brush they can be faded and blended. Other details and sharper lines were made with coloured pencils used with variable pressure.

Using your imagination

Not everything you draw has to be representational (that is, representing what is actually seen). Although many drawings need to be factual and accurate, others can give you the opportunity to show what you think or feel about something. You can try out your imagination and skill to express your own opinions, ideas and personality.

So how can you communicate these very personal ideas through the medium of drawing? The first point is that you have got to feel very strongly about the idea, you've got to be really interested in it, and *want* to express it. As with any drawing, if you become involved and enthusiastic you are more likely to succeed. You can then use different techniques and media or a particular style to emphasize the point you want to make. As in

a speech or a piece of writing, your message won't come across unless you emphasize it. So you may need to aim for a particular mood and feeling in the drawing or you may have to distort shapes or exaggerate colour. Apart from the subject matter, the use of an unusual viewpoint, perhaps distorted perspective or scale, and heavy contrasts of light and dark, can all help to make a really positive and personal statement.

Some people are much more imaginative than others, of course. Whatever sort of artist, you need to work with some imagination. Trying out one or two drawings like those in illustrations **1** and **2** will make you work in a much broader context, will stretch your imagination and widen your general experience – and that can benefit all your work. Your imagination can be fired by a number of sources: by an interest in topics

1

2 Milton's Paradise Lost, *by John Martin. Ink.* *Williamson Art Gallery and Museum, Metropolitan Borough of Wirral*

like science fiction and mythology; by 'pictures' conjured up from reading books and poems; by personal experiences and travel; by developing ideas from some of your other representational drawings in a more personal way; by looking at the work of other artists; and by setting yourself a theme to research and develop in an imaginative way.

You can see an example of a drawing developed from a theme in illustration **1**. This is based on the theme of 'The Unexpected' and is drawn in ink and pencil techniques. Set yourself a theme that will stimulate lively work, for example, 'The Forgotten City', or 'Overgrown', or 'Back to Front'. If ideas fail you, open the dictionary at a random page and set yourself the task of illustrating a word from that page!

Alternatively, think about ideas and situations in books you have read, or try to illustrate the theme of a poem or part of a poem, as in illustration **2**. You can 'borrow' ideas from other sources but remember that particularly with this type of work it is eesential that your ideas are original.

You may need to plan your work through the sort of drawing process described in Section 4. The content of the drawing doesn't have to be entirely fantastic, but can rely instead on real objects and people in an unusual or unreal setting. But don't overplan and overwork your idea to the extent that it loses its vitality. As in the two examples shown, think of the best media and techniques to fit the sort of mood and impact you want to create.

1 (Left) 2 (Right)

Abstract drawings

Abstract is a term that is not easily understood and consequently not easily accepted or appreciated. Achieving a faithful likeness in a portrait drawing, or producing a skilful and evocative landscape, seems to have a more obvious point, and so, to some, an abstract drawing will seem worthy of only scathing comment. But not all abstracts are meaningless and a waste of time and effort. They may stem from a different source – internal rather than external – but may, nonetheless, be produced with as much skill and possibly even greater sensitivity and impact than their representational rivals!

An abstract won't be striving for a likeness, and it won't be based on reality. But it will be just as concerned with many of the topics discussed in relation to more conventional methods of drawing – line, shape, colour, tone, texture, composition and so on. Indeed, in an abstract drawing these elements may have an even greater significance. Abstract drawings fall into three main categories: those that started from observation studies, but through a process of simplification, elimination or distortion have caused the result to be non-representational (illustration **5**); those that are based on the use of lines and geometrical shapes arranged in a deliberate way (illustrations **1** to **3**); and those that make use of random and uninhibited marks and

shapes to produce a free and expressive result (illustration **4**).

For the beginner, drawing abstracts can be useful. Take drawings like the ones shown in **1** to **3**. Even if drawn in a mechanical way, they will help with the confident handling of lines and shapes, and with the manipulation

3

1

The meandering line creates various shapes which can be carefully coloured in, in this case with coloured Conté pencils. Incidentally, particularly in abstract work, if a line needs to be absolutely straight, then use a ruler. You could vary this with freehand lines, curved lines, circles, and so on.

Use a card template for the sort of repetitive line in **3**. Use a strip of card and cut the outline shape from one edge. Place the template at the top of the paper, draw along the edge to make the first line, move it down slightly to repeat the line, and so on. Experiment with the spacing of lines and combination of colours. Keep your pencils sharp.

You can really have some fun in a drawing like illustration **4**! Try out a range of different media and techniques, but aim to keep some sort of order in the drawing. They needn't be 'all over' drawings, but may have some sort of focal point. I have tried to make most of my lines and shapes radiate out from the blue area near the top right-hand corner. Illustration **5** is fun too. Here, two drawings of equal dimensions have been cut into strips, taking a strip from each drawing in turn to assemble a new design.

of different drawing media. They will encourage you to look at the basic arrangement of line, shape and form, which, after all, is important in any sort of drawing. Try out a whole range of media and ideas. Have fun, but remember that, like any drawing, abstracts should be more than just a pretty pattern or something to complement the wallpaper!

Take the general ideas shown on this page as starting points and develop your own variations from them. Try some simple line designs to start with. You can build up an interesting design using a grid, as the structure for your drawing and as a unifying element (as, for example, in illustration **1**). Start with straight lines used in different directions. In this kind of abstract there is generally some sort of system, or 'rule', that applies. Here, you will see that I have limited each colour to a certain direction: red is horizontal, for example, and green diagonal. This sort of limitation stops the design becoming totally disorganised and disjointed; it gives it a theme and a coherence. Remember how lines can be used in all sorts of different ways: for spacing, and strength, and so on. Look back at pp. 26–27 to see what other qualities of line you could explore in an abstract way.

My drawing in illustration **2** uses a simple, continuous line as the basis for the design.

5

FRAMING *and* PRESENTATION

Not all drawings are designed as exhibition pieces. Some drawings are part of a series, or a stage, or a process towards a final result. As you have seen, many drawings are done as research and planning. However, a drawing that is particularly satisfying is well worth the trouble of mounting and framing and displaying in your home, or even in an exhibition.

Ideally, you are the best person to make the mount and frame, since you did the drawing and will have strong views on what will enhance it and present it to the best advantage. The type of mount and frame will obviously affect the impact of your finished creation. If you have the opportunity to try out a number of different mounts you will see what I mean. In addition, a poorly-cut mount or a badly-made frame will certainly detract from the drawing, and therefore be a negative

rather than a positive factor. Work slowly and methodically. Double check measurements – precision is a must. But do have a go. If you are not satisfied with your efforts, then have the work framed by a professional.

Before you make the mount, check the drawing and clean off any unwanted marks. If necessary, spray it with fixative (*see* p. 23) to prevent it smudging. Trim the drawing to a size that leaves a 2.5 cm (1 in) margin for fixing to the back of the mount. For a drawing that goes to the very edges of the paper and has no such margins, you must either be prepared to

3

4

1

2

lose the edges of the drawing beneath the mount, or to flat mount the drawing first by gluing it to a larger sheet of thick paper.

Cutting mounts is explained opposite, and choosing mounts and frames on p. 90. See also the list of suppliers on p. 92.

Cutting mounts

The drawing can be flat mounted, window mounted or double mounted. First, determine the size of your mount. Place the drawing on a sheet of mounting card and judge what depth of margin around the drawing seems best. Traditionally, watercolours, small drawings and line drawings have proportionally wide margins. Drawings that are bold and more intense may

need less of a margin. With very large, powerful drawings, like charcoal drawings, you could abandon the mount altogether and take the drawing to the edge of the frame. Work on the general assumption that the average A3 drawing needs a margin of 6.5 mm (2½ in). Look at the mounts shown on the opposite page. You can have an equal margin all round your drawing (illustration **1**) or, more conventionally, have a wider margin at the bottom (illustration **2**). Bear in mind that the size of your mount may have to fit a particular size of frame.

Think also at this stage whether you want the drawing to be double mounted, as in illustration **3**, or whether you will use a pen line to give the illusion of recession and provide a bolder edge to the drawing, as in the mount in illustration **4**. A double mount consists of the first mount cut from thin card, usually white, and then a second mount placed over this. The margins of the second mount are not quite as wide, so this leaves a narow, contrasting edge round the drawing, as in illustration **3**.

For a flat mount, cut a sheet of backing card of the right proportions for the drawing. Work out the position of the drawing on the backing sheet and mark each corner with a faint pencil point. Quickly apply some glue to the back edges of the drawing, as shown in illustration **5**, re-position it on the card and press in place, as shown in **6**. You could use two colours for a double mount.

A window mount is basically a card frame. You can cut the mount either with a 90-degree cut using a craft knife, or at an angle of 45 degrees using a mount cutter. Again, cut the card to the correct proportions for your drawing and this time mark out the shape of the drawing on the back of the card. Measure precisely! Like illustration **7**, use a craft knife or mount cutter against a metal straight-edge to cut out the centre of the card. Check the position before using some adhesive tape to secure the back edges of the drawing to the underside of the mount (*see* illustration **8**).

Sometimes, if the drawing has been made on very thin paper, or the paper has wrinkled or distorted, the drawing may need gluing to a backing sheet before it is mounted.

5

6

7

8

Choosing mounts and frames

There has to be some sympathy between mount and frame, and remember that the purpose of both is to enhance your drawing and to provide a space around it that concentrates the viewer's attention on the work itself.

As for the mount, sometimes a hint of colour may liven up the drawing, but more often a neutral mount of grey, sepia, off-white, cream or pale peach is best. If the drawing is in colour then the colour of the mount can relate to predominant tones in the drawing. If possible, lay the drawing on sheets of mounting card of different colours to determine which is most suitable. Decide whether you want a plain card or something with a texture. Look at some sample types and colours in illustration **4**.

I would not recommend investing in a lot of expensive equipment and materials to make frames, but by all means do this if you have some carpentry skills. Otherwise you can have frames specially made up for you from a supplier or craft shop; you can recondition old frames purchased from market stalls and junk shops; or you can buy cheap framed prints, throw away the print and re-use the

frame! Obviously, try to match your frame to the type and colour of the mount used.

An inexpensive method of framing is the glass and backing board one shown in illustration **1**. You can make this yourself to fit the size of your mount. Buy a sheet of 2 mm ($^3/_{16}$ in) picture glass, the same size as your mount, and likewise a sheet of hardboard or plyboard. Assemble the picture as shown in the illustration.

When ordering frames from a supplier or craft shop take some care over the choice of moulding. The width of the moulding should relate to the size of the mount. Look at illustration **2**. Small drawings are usually best with a plain moulding in natural wood. Larger drawings can take a proportionately wider moulding. Similarly, an abstract is normally best with a plain moulding of natural wood or a single colour, whilst a more intricate landscape might benefit from something a little more ornate.

Alternatively, you can reuse old frames by stripping them of their varnish with glass-paper, regluing and repinning the joints and painting them in an appropriate colour.

Have a look at the way the drawing and mount are assembled within the frame in **3**. See also the list of suppliers on p. 92.

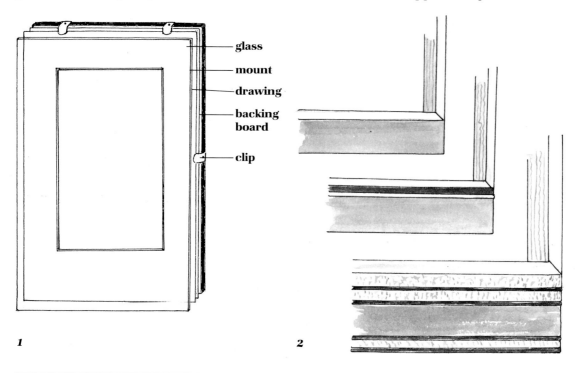

glass

mount

drawing

backing board

clip

1

2

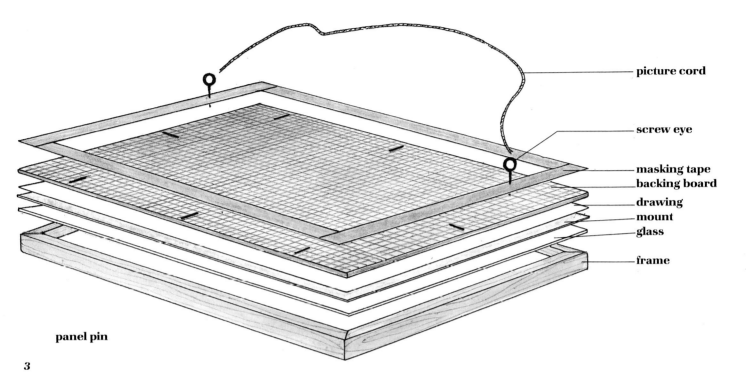

picture cord

screw eye

masking tape
backing board
drawing
mount
glass
frame

panel pin

3

4

USEFUL ADDRESSES

GREAT BRITAIN

Browsing in a good art and craft shop will give you first hand experience of different materials, and you may have the opportunity to test some out. The suppliers listed below will send you catalogues: if they are not prepared to supply you directly, then ask a retailer to order the materials for you.

General art materials and equipment

Fred Aldous The Handicrafts Centre 37 Lever Street Manchester M60 1UX

Art and Crafts 10 Byram Street Huddersfield HD1 1DA

Crafts Unlimited 178 Kensington High Street London W8 (and branches)

Daler-Rowney and Co. Ltd 10 Percy Street London W1

Reeves and Sons Ltd Lincoln Road Enfield Middlesex

Winsor and Newton Ltd 51 Rathbone Place London W1 (and branches)

Drawing pens, pencils and crayons

Berol/Venus Oldmedow King's Lynn Norfolk PE30 4JR (pencils and felt-pens)

Cosmic Crayon Company Ampthill Road Bedford (Wax crayons)

Jakar International Ltd Hillside House 2–6 Friern Park London N12 9BX (Caran d'Ache water-soluble pencils)

KW Pens 9 Kenion Road Rochdale Lancs OL11 5JX (pens and pastels)

Rexel Cumberland Pencils 36 Edison Road Rabans Lane Industrial Estate Aylesbury Bucks HP19 3AS

Rotring Strathcona Road Wembley Middlesex HA9 8QP (art pens, technical pens and ink)

Staedler Norris Pontyclun Mid-Glamorgan CF7 8YJ (pens and pencils)

Paper

Atlantic Paper Company Ltd Gullivers Wharf 105 Wapping Lane London E7 9RW

Falkiner Fine Papers Ltd 76 Southampton Road London WC1B 4AR

F. G. Kettle 216 Tottenham Court Road London W7

Spicer Hanbury Company Ltd Peterborough Road Fulham London SW7

Try your local printer for paper offcuts

Framing

Chatfields Ashlea Studio 41 Ecton Lane Sywell Northamptonshire NN6 0BA

Key Products Ltd Bantel Works Rye Road Hoddesdon Herts EN11 0DU

Thirkill's Scoresby House 13 Flowergate Whitby North Yorkshire

Publishers of art books and books on art and craft techniques

B. T. Batsford Ltd 4 Fitzhardinge Street London W1H 0AH

Blandford Press Link House West Street Poole Dorset BH15 1LL

Collins 8 Grafton Street London W1X 3LA

David and Charles Brunel House Newton Abbot Devon TQ12 4PU

Dorling Kindersley 9 Henrietta Street Covent Garden London WCZE 8PS

Faber and Faber 3 Queen Square London WC1N 3AU

Kaye and Ward Windmill Press Kingswood Tadworth Surrey KT20 6TG

Macdonald 63–72 Shoe Lane Holborn London EC4P 4AB

Phaidon Press Musterlin House Jordan Hill Road Oxford OX2 8DP

Thames and Hudson 30–34 Bloomsbury Street London WC1B 3QP

Write for Publisher's list

Magazines

The Artist 63–65 High Street Tenterden Kent TN30 6BD

The Artists's and Illustrator's Magazine 4 Branden Road London N7 9TP

Arts Review 69 Faroe Road London W14 0EL

Leisure Painter 63–65 High Street Tenterden Kent TN30 6BD

Where to see drawings

Many provincial museums and art galleries have drawings in their collections. Sometimes, through lack of hanging space, not all the drawings are displayed. The Curator will normally be willing to show you folios of drawings by particular artists or of particular subjects which interest you. Some of the most extensive collections are at:

Birmingham City Museum; The Fitzwilliam Museum, Cambridge; The National Museum of Wales, Cardiff; The Burrell Collection, Glasgow; The British Museum, London; Courtauld Institute Galleries, London; National Portrait Gallery, London; Tate Gallery, London; Victoria and Albert Museum, London; Manchester City Art Gallery; Ashmolean Museum, Oxford; Glyn Vivian Gallery, Swansea; Windsor Castle, The Royal Library.

Art Clubs and Societies

Many towns have an art club or society which meets on a regular basis for working sessions, demonstrations and perhaps excursions, and usually with an annual exhibition. Details should be available in your local library.

Classes and courses

The National Institute of Adult Education, 35 Queen Anne St, London W1, will provide a list of residential short courses covering a wide range of art and crafts. Contact your local Education Authority to find out which schools and colleges run evening classes in your area.

There are many summer schools and weekend courses run by practising artists, and also organized holidays to draw and paint in other parts of the world. These are advertised in magazines such as Leisure Painter and The Artist.

Exhibiting your work

Whether you belong to an art club or not, there are normally other local exhibitions in which you can take part. More prestigious and national

exhibitions and competitions, are advertised in art magazines.

Work for an exhibition must of course be mounted and framed under glass, and may need to conform to certain restrictions regarding subject matter and technique. Some exhibitions, for example, are purely for work in a single medium, such as pastel. Check the details before submitting work.

U.S.A.

There is no substitute for being able to experiment with an individual medium and checking its suitability for your particular work. If possible, visit a good retail store for help and advice. The following suppliers will supply materials by mail order, or otherwise via a retail outlet.

General art materials and graphic art suppliers

Alvin and Co Inc 1335 Blue Hills Avenue Bloomfield CT 06002

Binney and Smith Inc 1100 Church Lane Easton PA 18044

Dick Blick Company Rte. 150 East P.O. Box 1267 Galesburg IL 61401

Chartpak One River Road Leeds MA 01053

The Fax Company 62 East Randolph Street Chicago IL 60601

New York Central Art Supply Inc 62 Third Avenue New York NY 10003

Palette Shop Inc 342 N. Water Street Milwaukee WI 53202

Peal Paint Co 308 Canal Street New York NY 10013

St. Louise Crafts Ltd 44 Kirkham Industrial Court St. Louis MO 63119

Visual Arts Systems Company Inc 1596 Rockville Pike Rockville MD 20852

Fine line and other markers

Magic Marker Industries Inc 467 Calhoun St Trenton NJ 08618

Paper

Andrew/Nelson/Whitehead Paper Corporation 3– 10 48th Avenue Long Island City NY 1101

Rupaca Paper Corp 110 Newfield Avenue Edison NJ 08818

Strathmore Paper Company South Broad Street Westfield MA 01085

Studio equipment/air brushes

Artist & Display Supply Inc 9015 West Burleigh Street Milwaukee WI 53222

Sam Flax Art Supply Co 39 West 19th Street New York NY 10011

Framing

Presto Picture Frames 1237 Shipp Street Hendersonville NC 28739

Publishers of art books

R. R. Bowker Co 245 West 17th Street New York NY 10011

George Braziller Inc 60 Madison Avenue Suite 1001 New York NY 10011

David R. Godine, Publishers Inc Horticultural Hall 300 Massachusetts Avenue Boston MA 02115

Little, Brown and Company 35 Beacon Street Boston MA 02108

Lyons and Burford 31 West 21st Street New York NY 10010

Pantheon Books 201 East South Street New York NY 10022

Schocken Books Inc 201 East 50th Street New York NY 10022

Taplinger Publishing Co Inc 238 West 72nd Street New York NY 10023

Van Nostrand Reinhold 115 Fifth Avenue New York NY 10003

Viking Penguin Inc 40 West 23rd Street New York NY 10010

Watson-Guptil Publications New York NY 10036

Write for Publisher's list

Magazines

Artists' Magazine F. & W. Publications Inc 1507 Dana Avenue Cincinnati OH 45206 (practical step-by-step instructions)

Draw Magazine Calligrafree 43 Anaka Avenue Box 98 Brookville OH 45309 (Pen and ink, brush drawings etc)

Illustrator Art Instruction Schools 500 South Fourth Street Mineapolis MN 55415

Where to see drawings

There are many city, state and university art galleries where drawings are on permanent view or can be seen on application to the Director. The *Official Museum Directory* published by Macmillan Directory Division, Third Avneue, New York, NY 10022, lists all the art museums and galleries in the U.S.A. Some of the best known collections are:

Baltimore Museum of Art; Cooper Union Museum, New York; Fogg Art Museum, Cambridge MA;The J. Paul Getty Museum, Malibu CA; The Metropolitan Museum of Art, New York; The Museum of Modern Art, New York; National Gallery of Art, Washington DC; The Phillips Collection, Washington DC; Pierpont Morgan Library, New York; Philadelphia Museum of Art; Smithsonian Institution, Washington DC; Solomon R. Guggenheim Museum, New York; Wadsworth Atheneum, Hartford CT.

Classes, courses and art societies

For an extensive list of art museums, schools and associations in the U.S. and Canada consult the *American Art Directory*, published by R. R. Bowker Co, 245 West 17th Street, New York NY 10011.

The *American Artist and Art School Directory*, published by Billboard Publications Inc, 1515 Broadway, New York City, NY 10036, lists educational and instructional opportunities – schools, colleges, workshops and private teachers.

Exhibiting your work

Venues and competitions are advertised in art and craft magazines, especially the *Art and Craft Catalyst*, Box 433, South Whitley, IN 46787.

GLOSSARY

Check the **Index** for other references to terms and techniques.

Abstract A drawing that doesn't try to repeat something from the real world but relies instead on the use of geometrical or random shapes, lines, textures and colours. You can *abstract* a design by a process of simplification and distortion, so that the original shapes are no longer recognizable.

Acetate A clear plastic film used for protecting drawings and making overlays, grids, etc.

Airbrush A mechanical tool for controlled fine spraying with ink or paint.

Assemblage Cutting shapes from several drawings and gluing them to a fresh sheet of paper to form a new design.

Asymmetrical A shape or composition that, when divided along its central axis (more or less in half), is not identically balanced.

Background The area of the drawing that surrounds, or is behind, the main and more detailed parts.

Backing Hardboard or stiff cardboard used at the back of a frame, to help strengthen it, and to protect the drawing from dust and moisture.

Bleed The blurring of the edges of a line or an area of wash, caused by applying a dry medium on or against a wet one, or by using the wrong sort of paper.

Cartoon A full-size design, usually in chalk or charcoal, that can be transferred on to a canvas to give the outline for a painting.

Chiaroscuro Contrasts of light and dark in the shading of a drawing.

Collage Making a picture by cutting or tearing shapes from paper or other materials – maybe some old, unloved drawings!

Composition The arrangement of the main shapes of a drawing so as to form a particular design.

Drawing elements Line, point, tone, texture, colour, form, shape and pattern.

Draughtsmanship Skill in drawing.

Evaluation Looking critically at a completed drawing and assessing how successful it has been.

Figure The human figure.

Focal point The part of the drawing that attracts the most attention. Often the composition is so devised that shapes and lines lead you to a particular object of interest.

Foreground The part of the drawing that shows the area nearest to you and that will normally include the most defined and detailed shapes.

Foreshortening The use of perspective on an object which is coming directly towards you. This gives a very obvious contrast in scale between the nearest and furthest parts.

Form The three-dimensional shape of something.

Foxing Brown spotting of drawings caused by dampness.

Gradation The gradual transition from one tone to another without any noticeable edges.

Grid Dividing the drawing into squares to help with composition or

1 Sgraffito drawing

enlarging. You can keep a sheet of tracing paper or acetate with squares drawn over it ready for this purpose.

Hatching Using short, closely spaced, straight lines to suggest an area of shadow or texture.

Highlights The very lightest area in a drawing; usually those parts that attract or reflect the greatest amount of light.

Image The shape of something.

Landscape Apart from drawings depicting open countryside, this term is applied to the general shape of a drawing in which the horizontal measurement is significantly greater than the vertical one.

Lay figure A small wooden, jointed figure made to the correct human proportions. It can be adjusted to a variety of poses as an aid in figure drawing.

Light-box A device consisting of a box with a glass or clear perspex lid, being lit from inside by a bulb or fluorescent tube. Drawings placed on the top can easily be traced off. Taping a drawing to the window works nearly as well!

Masking fluid A liquid used to block out parts and fine details, which you don't want to cover when applying a wash or spray. It dries as a rubbery film and can easily be removed when required.

Medium Any drawing material: pencil, pastel, charcoal, ink, and so on.

Mixed media Combining several different media within the same drawing.

Monochrome Using a single colour or a range of tones of one colour to make a drawing.

Monotone Using a single tone plus areas of white; normally a black and white drawing.

Natural forms Things found in nature, such as flowers, leaves, shells, bark, fish and so on.

Objective drawing Aiming for real accuracy in showing a true likeness of something.

Offsetting Transferring marks made on one sheet of paper on to a fresh sheet to make another drawing. Therefore you need to use a wet medium, like ink or paint, or something that leaves a dusty deposit, like pastel or charcoal. Simply press the second sheet of paper firmly down over the original drawing. You can also create offset marks by dipping a piece of card or a small object into some ink and pressing it down on a sheet of paper.

Overworking Developing a drawing in a different technique or medium over the top of tones or colours that have already been applied.

Perspective A drawing technique for creating the illusion of space and distance.

Portrait Not just a drawing of someone's face, but also used to describe the shape of a drawing in which the vertical dimension is greater than the horizontal one.

Register Keeping one sheet of paper exactly in the right position in relation to a second sheet, for example when making monoprints or tracings.

Schema A simple line drawing to show the arrangement of shapes in a composition or the structure of a figure or object.

Scraperboard Specially prepared board that you can draw on by scratching through the black surface to reveal the white coating underneath. A lively graphic technique, this gives a result similar to a wood engraving.

Sfumato The skilful blending of soft tones of shading so that there is not detectable transition.

2 Thumbnail sketch

Sgraffito Drawing by scratching through one layer of colour to reveal a contrasting colour underneath. For example, you can scratch lines through black wax crayon that has been applied over another colour, as in illustration **1** (*opposite*).

Shading Applying light and dark areas to a drawing to give the feeling of shadows and help create three-dimensional effects.

Stencil A sheet of card with a shape or a number of shapes cut out from it. You can use this to repeat the shapes in a pattern or spray or stipple over it.

Support What you use to draw on, for example, paper or card.

Symmetrical Completely balanced. A shape in which, if divided in half, the right-hand half would be exactly the reverse of the left-hand half.

Template A silhouette shape cut from thin card, which you can use to draw round, usually to make a repetitive design.

Thumbnail sketch A small sketch to give the brief outline of an idea. See illustration **2** (*above*).

Tide marks Where an area of wash has dried unevenly to leave obvious 'joins' between one application and the next.

Tint A very light tone of colour.

Tone The relative lightness or darkness of a colour or the progression from black, through various greys, to white.

Tracing box *See* light-box.

INDEX